IMAGES
of America

HILTON VILLAGE

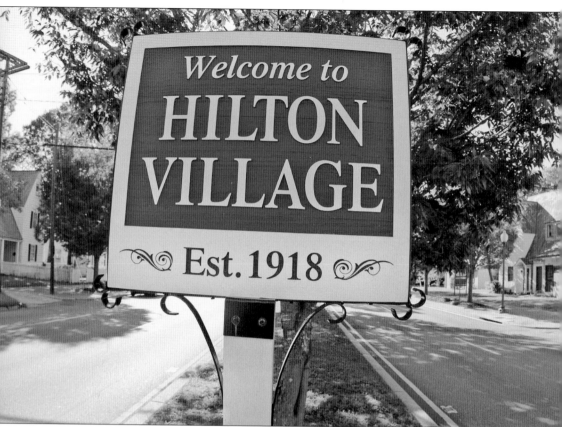

The sign at Main Street and Warwick Boulevard welcomes visitors to the Hilton Village Historic District. (Courtesy of Michael Poplawski.)

ON THE COVER: In a photograph by E.P. Griffith, workers construct Post Street after their shift at Newport News shipyard. (Courtesy of Newport News Shipbuilding.)

IMAGES
of America

HILTON VILLAGE

John V. Quarstein

ARCADIA
PUBLISHING

Published by Arcadia Publishing
Charleston, South Carolina

Printed in the United States of America

Library of Congress Control Number: 2017961417

For all general information, please contact Arcadia Publishing:
Telephone 843-853-2070
Fax 843-853-0044
E-mail sales@arcadiapublishing.com
For customer service and orders:
Toll-Free 1-888-313-2665

Visit us on the Internet at www.arcadiapublishing.com

I dedicate this volume to my son, John Moran, and his mother, Martha Carol Jones Quarstein, as they epitomize the magic that is Hilton.

—JVQ

CONTENTS

ACKNOWLEDGMENTS

Special thanks go to Julie Murphy, photo researcher and editor; Jamey Bacon; librarian Susan Connor, *Daily Press*; Elizabeth Lankes; Bill Lee, alumnus of the Apprentice School and member of Warwick Volunteer Fire Department; J. Michael Moore, curator, Civil War Sites, City of Newport News; Newport News Shipbuilding; Michael Poplawski, director, Newport News Parks, Recreation and Tourism; Mayor McKinley L. Price, DDS, City of Newport News; Dr. Wellford Dunaway Taylor; Howard H. Hoege III, president and CEO, Library, and Digital Services, The Mariners' Museum and Park; Colleen Raven Thorpe; librarian Jillian Wagner, Virginiana Room, Newport News Public Library; Historic Hilton Village Inc.: John Lash, president, Chuck Webb, historian, the Centennial Committee and its more than 100 community volunteers.

Thanks go to the many former and current Hilton residents and business owners who generously shared stories and photographs from their lives in the village. My neighbors, friends, and colleagues with whom I talked, played, and worked during my 21-year Hilton experience made those years among my most memorable.

Images in this volume appear courtesy of the Library of Congress (LOC), Newport News Shipbuilding (NNS), Newport News Public Library (NNPL), The Mariners' Museum and Park (TMMP), and others.

HARVARD IMAGE CITATIONS

Page 53
Unidentified Artist
Housing, Government: United States, Virginia. Newport News: Governmental Agencies of House Construction. U.S. Shipping Board, Emergency Fleet Corporation: The Emergency Fleet Corporation USSB Housing at Newport News, Virginia. Francis Y. Joannes Architect New York NY: Five Family Group: First Floor Plan: Second Floor Plan, c 1918.
Collotype: image: 29 x 20 cm (11 7/16 x 7 7/8 in.)
Harvard Art Museums/Fogg Museum, Transfer from the Carpenter Center for the Visual Arts, Social Museum Collection, 3.2002.2076.2
Photo: Imaging Department ©President and Fellows of Harvard College

Page 56
Unidentified Artist
Housing, Government: United States, Virginia. Hilton Village: Governmental Agencies of House Construction. U.S. Shipping Board, Emergency Fleet Corporation: The School Building, Hilton Village, Virginia. Francis Y. Joannes, Architect, 1918, c. 1918.
Collotype: image: 27 x 19.5 cm (10 5/8 x 7 11/16 in.)
Harvard Art Museums/Fogg Museum, Transfer from the Carpenter Center for the Visual Arts, Social Museum Collection, 3.2002.2075.1
Photo: Imaging Department ©President and Fellows of Harvard College

Page 73
Unidentified Artist
Housing, Government: United States, Virginia. Hilton Village: Governmental Agencies of House Construction. U.S. Shipping Board, Emergency Fleet Corporation: Shops and Theatre on the Village Square, Hilton Village, Virginia. Francis Y. Joannes, Architect, 1918, c. 1918.
Collotype: image: 14 x 28.5 cm (5 ½ x 11 ¼ in.)
Harvard Art Museums/Fogg Museum, Transfer from the Carpenter Center for the Visual Arts, Social Museum Collection, 3.2002.2075.2
Photo: Imaging Department ©President and Fellows of Harvard College

Page 157
Unidentified Artist
Housing, Government: United States, Virginia. Newport News: Governmental Agencies of House Construction. U.S. Shipping Board, Emergency Fleet Corporation: The Emergency Fleet Corporation USSB Housing at Newport News, Virginia. Francis Y. Joannes Architect New York NY: Semi-Detached Houses: First Floor Plan: Second Floor Plan, c 1918.
Collotype: image: 27 x 19.5 cm (10 5/8 x 7 11/16 in.)
Harvard Art Museums/Fogg Museum, Transfer from the Carpenter Center for the Visual Arts, Social Museum Collection, 3.2002.2076.2
Photo: Imaging Department ©President and Fellows of Harvard College

INTRODUCTION

One of the most remarkable and lasting stories of Newport News's World War I experience is that of Hilton Village. Hilton was the first planned government housing project in the United States. Its construction was spurred on by Newport News Shipbuilding president Homer Lenoir Ferguson. Ferguson's dramatic appearance before a US Senate subcommittee in Washington, DC, awakened officials to the alarming civilian housing shortage related to the war effort. In response, the US Shipping Board, Emergency Fleet Corporation, and other federal agencies established a housing program. Newport News received the Riverside (also known as Shipyard) Apartments and Hilton Village. Hilton, in effect, was the project's pilot program.

Once funding was identified, a 200-acre parcel known as the Darling Tract was acquired. Located on a bluff overlooking the James River, it was four miles west of downtown Newport News via the Great Warwick Road. Hilton's planning was accomplished by renowned town planner Henry Vincent Hubbard of Harvard University, who was author, along with his wife, Theodora Kimball Hubbard, of *An Introduction to the Study of Landscape Design*. Francis Y. Joannes was engaged as the architect. Joannes studied at the École des Beaux-Arts in Paris and was noted for such monumental buildings as the Department of Justice in Washington, DC. Together, they created an ideal village of 500 English cottage–style homes. It was to be a complete town with roads, fire protection, schools, stores, churches, parks, and playgrounds. A trolley line connected Hilton with the shipyard, making the village one of the first examples of the New Urbanism and Garden City movements in America. Hubbard believed his team was "an outstanding innovation to the new city-planning movement."

Hilton Village was formally dedicated on July 7, 1918. Many people denied that the war would be ending soon. One construction worker wrote on a board's lip in his Ferguson Avenue home: "Job done by Gerald Rex Swoope, Morrison, Virginia, September 14, 1918. Allies winning on the western front. Germans driven back." Within two months, the war was over. The Hilton project was still unfinished, and workmen continued to construct houses and the Hilton Village School until most everything was completed as conceived by the designers. By 1920, every house was leased; however, Henry E. Huntington's Newport News Realty Company purchased all of the structures and parcels from the federal government at auction in 1922, then sold the properties to small business and home owners.

The village continued to be a vibrant part of Warwick County, despite its Newport News connections, and eventually became the governmental center of the new city of Warwick until consolidation with the city of Newport News. By the 1970s, the village had begun to show signs of decline. Businesses had moved to nearby shopping centers. Many of the original residents had passed on, and suburban neighborhoods like Hidenwood and Denbigh beckoned families to locate there. Many still recognized the growing town's planning and enjoyed the Anglophile connections when strolling down streets to reach the businesses on Warwick Boulevard or to enjoy the sylvan sunsets on Hilton Pier.

In 1968, Hilton Village was placed in the National Register of Historic Places and, as a historic district, the Hilton Architectural Review Board was created and managed by the City of Newport News. The city's planning department was established to regulate improvements to structures, fences, and outbuildings. This review board ensured that Hilton would retain its unique English cottage–style architecture. An organization known as CHAR (Citizens for Hilton Area Revitalization) was formed to enhance Hilton's historic beauty, quality of life, and economic vitality. Grants were received to improve the streetscape. In 1996, the $3.3 million Main Street Library opened. The library's high-pitched roof, brick facade, and central bay windows beautifully reflect Hilton Village and symbolize the city's commitment to this historic district's future.

World War I was a boom time for Newport News. The port fulfilled its capacity for shipping war material overseas to the battlefront. The city was named the headquarters of the Hampton

Roads Port of Embarkation. The port's embarkation camps echoed the tramp of soldiers, and the chants of going "Over There" or "Back Home" could be heard daily. The shipyard worked around the clock, launching as many as three ships a day. In the midst of this beehive of activity, one of Newport News's greatest wartime legacies was constructed: Hilton Village.

Built out in the wilds of Warwick, Hilton appeared far-removed from the bustle of downtown Newport News. Yet World War II would witness the shipyard expanding and, once again, Newport News would serve as the center of the Hampton Roads Port of Embarkation. The war brought suburbia to surround Hilton Village as more people came to Newport News to complete war work. This growth continues as Hilton reaches its centennial.

Hilton will always be known as a great neighborhood in which to raise a family. The tree-lined streets, the sense that one lives in a truly special place, and the allure of the James River all combine to make the village a wonderful community. These assets nurtured some of the nation's greatest artists and writers. William Styron, Thomas C. Skinner, J.J. Lankes, and many others produced an amazing body of work that enthralls the world today.

Hilton Village is a dynamic Newport News community and remains extraordinary. Beyond the fact that Hilton Village is the first (and perchance the most successful) planned public housing project in the nation, the City of Newport News can continue to boast about its first planned community, its first National Register of Historic Places district, its distinctive architecture reminiscent of an English village, and its being home to the city's oldest school building. Besides these shining facts, it is the livability of Hilton Village that makes it such a special place. As one walks down the shaded roads perusing structures that might have been pulled from a Dickens novel, the vision remains apparent of the leaders Homer Ferguson, Henry E. Huntington, Henry Vincent Hubbard, and Francis Joannes, who collaborated on creating the lasting legacy of Hilton Village.

One

WELCOME TO THE VIRGINIA PENINSULA

One of the first landfalls made by the English colonists was at what is now called Newport News Point. Capt. Christopher Newport commanded three English ships that had crossed the Atlantic to establish the first permanent English colony in the New World at Jamestown Island, up the James River from Newport News Point. The colony eventually prospered by sending goods back to England such as wood, furs, and, most importantly, tobacco. When the colony was organized into counties, the Virginia Peninsula would be comprised of Elizabeth City, Warwick, York, James City, Charles City, and New Kent Counties. Hampton, on the Hampton River, was the major port, and the fort on Old Point Comfort was where every ship coming into the colony had to stop and pay custom duties. It was here in August 1619 that the first Africans landed in English-speaking America. Within 40 years, slavery would be established and form the backbone of cash crop agriculture. The Peninsula remained a farming community for the next 200 years. A resort industry had developed on Old Point Comfort along with the largest moat-encircled fort in America, Fort Monroe. When the Civil War erupted in 1861, Fort Monroe and Camp Butler were the only places on the Peninsula controlled by the Union. The Peninsula would be the scene of the Battle of Big Bethel, the Battle of Hampton Roads, and the 1862 Peninsula Campaign. Every major amphibious assault against Southern coastal cities was launched from Hampton Roads. When the war ended, devastation was everywhere and the town of Hampton was completely destroyed. Nevertheless, the Peninsula used its natural resources to reinvent itself, with Old Point Comfort, Buckroe Beach, and Bayshore becoming major beach attractions. The seafood industry boomed with the area waters' bounty of crabs and oysters. However, the biggest step to financial success was the arrival of railroad magnate Collis Potter Huntington with his Chesapeake & Ohio Railway. He built port facilities, and a new town called Newport News served as his Atlantic terminus. To complement the port, Huntington established Newport News Shipbuilding & Dry Dock Company in 1886. These assets would become valuable commodities when America entered World War I.

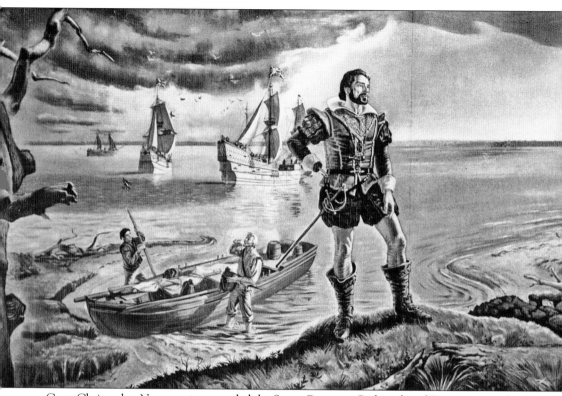

Capt. Christopher Newport commanded the *Susan Constant*, *Godspeed*, and *Discovery*, sent by the Virginia Company of London to establish the Virginia colony. The ships arrived at Cape Henry on April 26, 1607. Captain Newport then explored Hampton Roads. At the place that Capt. John Smith had called Point Hope, Captain Newport discovered two freshwater springs where he replenished their water supply before moving up the James River to establish Jamestown, the first permanent English settlement in the New World. Captain Newport commanded four more resupply voyages from England to Virginia during the colony's early days. Since Newport maintained a connection—the news—between England and Jamestown, the point where the James River emptied into Hampton Roads was named Newport News Point in his honor. Prior to his series

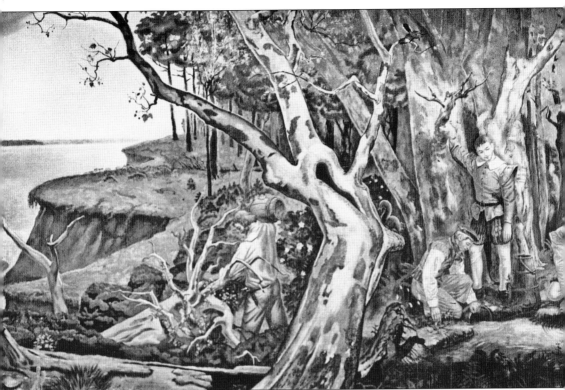

of voyages to Jamestown, Captain Newport had gained great fame and wealth during the Anglo-Spanish War as a privateer. While capturing one Spanish galleon in 1590, he lost his forearm during the engagement. In August 1592, he captured a Portuguese carrack, *Madre de Deus*, off the Azores, which contained 500 tons of spices, silks, gemstones, and other riches. It was the most valuable treasure ship captured by the English during the Elizabethan era. Following his service with the Virginia Company of London, Newport joined the Royal Navy and commanded three voyages for the East India Company. He died in Java sometime after August 15, 1617. (Mural by Allan Jones Jr., courtesy of NNPL.)

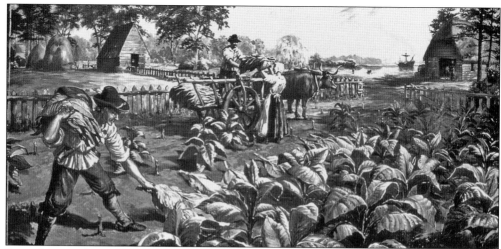

From the time the English colonists arrived in 1607, agriculture was the mainstay of the Peninsula's economy. Tobacco was king, and it flourished as a cash crop during the 17th and 18th centuries. This export brought tremendous wealth and influence; unfortunately, it also ruined the soil's productivity. As a result, the region became a backwater community and offered few economic opportunities. (Painting by Sidney King, courtesy of National Park Service.)

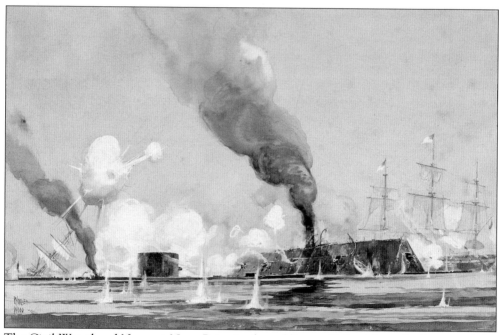

The Civil War placed Newport News Point in the public eye. Federal forces had occupied the area and created Camp Butler. The Confederate ironclad CSS *Virginia* (*Merrimack*) destroyed two Union warships, USS *Congress* and *Cumberland*, on March 8, 1862. The next day, the Union ironclad USS *Monitor* engaged the *Virginia* in the world's first encounter between ironclads. (Courtesy of TMMP.)

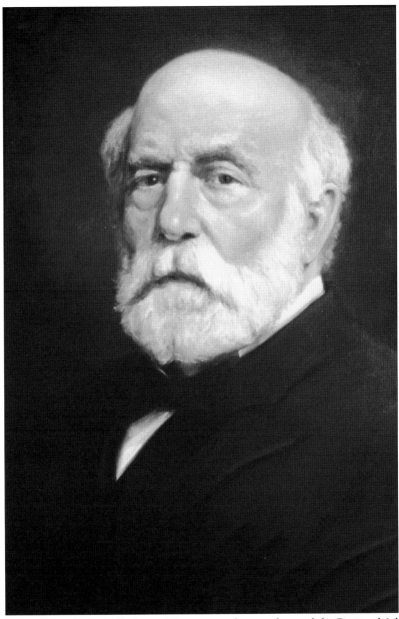

Dynamic railroad developer Collis Potter Huntington forever changed the Peninsula's landscape. Walter A. Post, one of Huntington's agents and later the first mayor of Newport News, described Newport News Point when he first arrived on November 26, 1880: "Scattered around on all sides were earthworks and other evidences of the late conflict between the states and desolation was everywhere. We were immediately struck with the magnificent possibilities afforded by the harbor and while we were impressed by the judgement and foresight manifested by Mr. Huntington, we wondered why this point had not long before been recognized and utilized as a site for a city. Early in December we began the work of construction and soon the scene of desolation was transformed into one of activity." C.P. Huntington had made a fortune in California building railroads. He believed that there was "no better place for a city" and selected the site to become the eastern terminus of the Chesapeake & Ohio (C&O) Railway. (Courtesy of NNS.)

Concurrent with the construction of the railroad, a new port city was built on the Peninsula. Two deepwater piers were completed in 1882. Six vessels were able to load simultaneously. The piers handled more than 100,000 tons of cargo during their first year of operation. By 1897, more than 600 vessels cleared the port, with cargo valued at more than $23.5 million. (Courtesy of NNPL.)

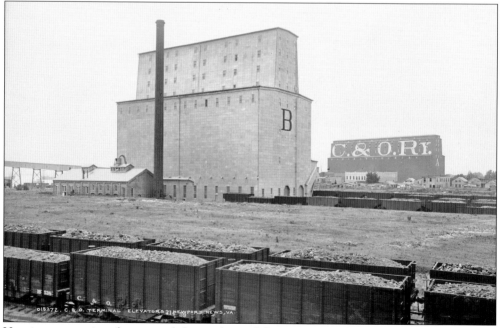

Huntington continued to expand the port's capabilities. A grain elevator with a capacity of 1.5 million bushels was completed in 1883, and a second one was built in 1902. These dominated the Newport News skyline as long as they stood. Grain Elevator A, built of wood and sheet metal, was destroyed in a devastating fire in 1915. (Courtesy of LOC.)

Seafood, a natural resource of the Hampton Roads region, was slow to develop on the Peninsula as a major industry. During the decades following the Civil War, the arrival of the C&O Railway transformed local oysters and crabs into an important commodity. The railroad established a spur line to Hampton to facilitate the shipment of succulent Hampton Bar and James River oysters to market. (Courtesy of TMMP.)

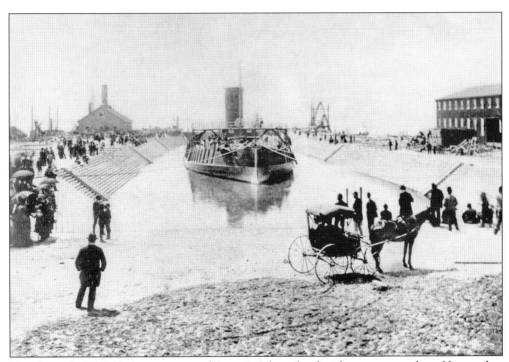

Huntington's C&O Railway connected America's heartland with overseas markets. He saw that he could build his own ships or repair others to carry coal from his coal mines, which was being delivered by his railroad to his port city. On January 28, 1886, the Chesapeake Dry Dock and Construction Company was chartered to "build and repair steamships, ships, vessels and boats of all dimensions." (Courtesy of NNS.)

Huntington intended to build "the best shipyard plant in the world" with the "reputation of building the best ships." On April 24, 1889, the dry dock was officially opened with the docking, at no charge to the US Navy, of the monitor *Puritan*. Huntington attended the ceremony and brought with him the famous poets Joaquin Miller and Walt Whitman, while Gov. Fitzhugh Lee represented the commonwealth. The creation of this bustling new community inspired Miller to write his poem "Newport News," which is perhaps the finest tribute ever accorded Huntington. The *New York Herald* wrote, "Newport News now has facilities for repairing the largest vessels afloat . . . what this section has needed for years. The formal opening marks a new era in the industries of Virginia . . . and will also have an important bearing upon the shipbuilding interests of this country." (Courtesy of NNS.)

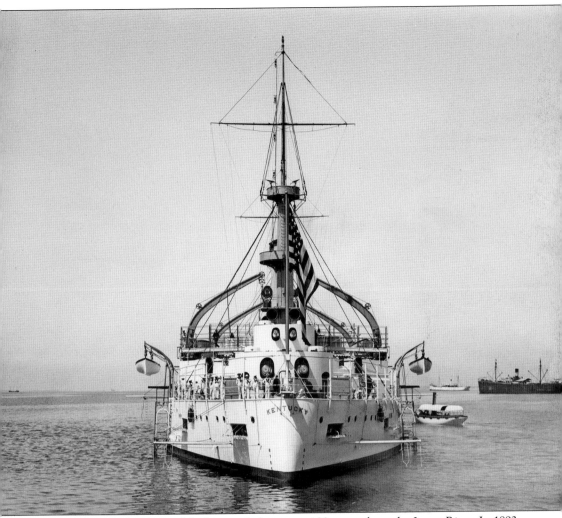

By the mid-1890s, the shipyard had expanded to cover 138 acres along the James River. In 1893, the Newport News shipyard bid successfully on three gunboats: *Nashville, Wilmington,* and *Helena.* Shipyard president Calvin Orcutt underbid $400,000 on the cost of these warships. Huntington wrote Orcutt, "In these matters do not charge too much. . . . I want you to turn out as good, or better, ships of this class. . . . The yard is new, and what I want is to get a reputation for building first class ships and then always build ships to sustain that reputation . . . it would be humiliating to have anything turned out from our yard that was not first class." The yard would expedite work for the US Navy when the USS *Maine* was sunk in Cuba's Havana Harbor on February 15, 1898. The yellow press formed popular support for the Spanish-American War. One of the biggest days in early shipyard history was the launching of the battleships USS *Kentucky* and *Kearsarge* on March 24, 1898. (Courtesy of NNS.)

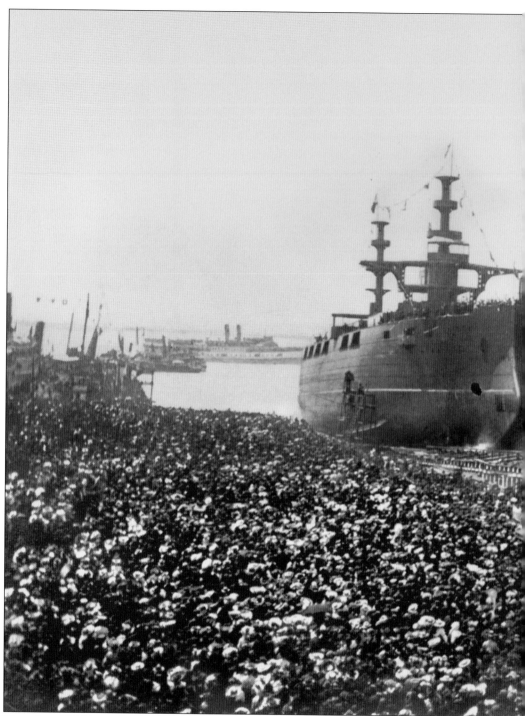

More than 18,000 people came to watch this grand patriotic event, a spectacular double battleship launching. The *Kearsarge* was the first to slide down the ways with a champagne bottle toast by Mrs. Herbert Winslow. The *Kentucky* followed shortly thereafter; the governor of Kentucky's daughter, Christine Bradley, chose to smash the bow with a bottle of spring water from the farm where Abraham Lincoln was born. While this was lauded by the Woman's Christian Temperance

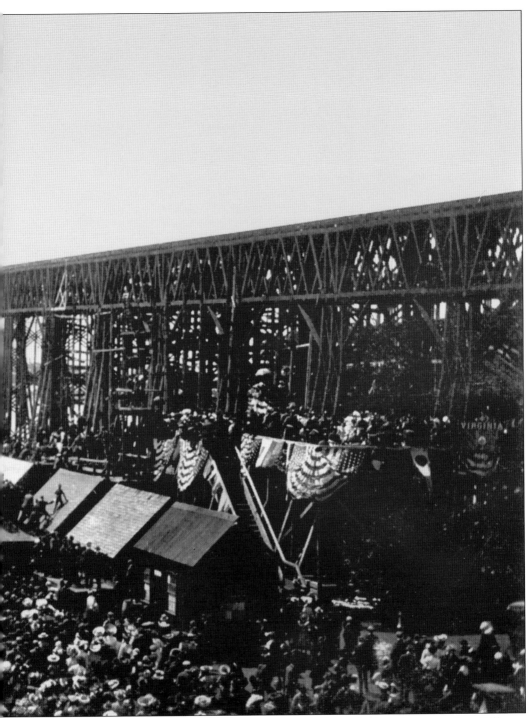

Union, a few "Kentucky colonels" were not so pleased. Some threw spring water from Jefferson Davis's birthplace, while others tossed bottles of bourbon. These two pre-dreadnought *Kearsarge*-class battleships each cost $4,998,119.43, and both ships participated in the cruise of the Great White Fleet. (Courtesy of NNS.)

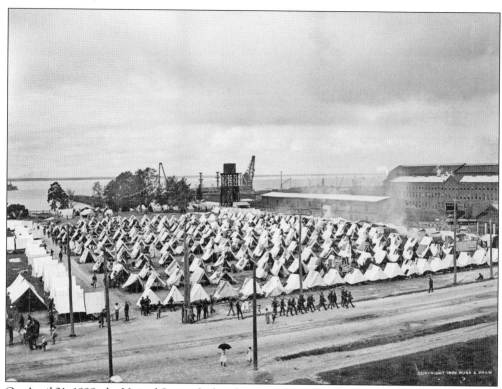

On April 21, 1898, the United States declared war on Spain. For the first time, the excellent port and rail connections would be used as a port of embarkation. Camps were laid out next to the C&O terminal. Local members of the Huntington Rifles guarded the waterfront from possible attack by the Spanish fleet while troops assembled for embarkation. The camps closed after the war. (Courtesy of TMMP.)

The C&O Railway helped foster tourism. The sea breezes along the Peninsula's waterfront were now accessible by rail and steamship. C.P. Huntington had this in mind when his Old Dominion Land Company opened the Hotel Warwick on April 11, 1883. The *Daily Press* reported a gala affair was enjoyed by some "200 prominent men and their wives of the Peninsula." (Courtesy of TMMP.)

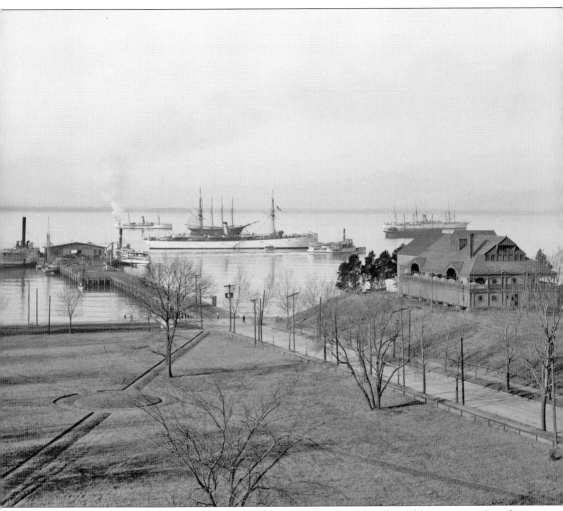

The Casino Grounds were directly in front of the Hotel Warwick. The Old Dominion Land Company created a park there that enhanced the hotel as a tourist attraction and provided recreational opportunities for residents. One advertisement noted how the hotel was situated on a bluff overlooking the James River and below "stretched a wide sandy bathing beach. Two long piers reached out into the river making this site one of the most colorful on the waterfront." The Casino Grounds Park included a bandstand, bowling alley, tennis courts, and a pleasure pier. At the end of Twenty-Eighth Street was Steamship Pier A, where steamers docked to unload their passengers and cargo. Steamboats such as the *Pocahontas* and *Hampton* provided overnight service between Norfolk and Richmond. (Courtesy of LOC.)

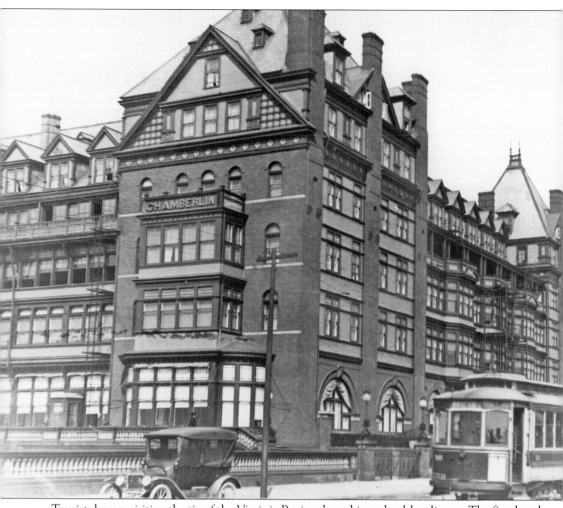

Tourists began visiting the tip of the Virginia Peninsula seeking a healthy climate. The first hotel, the Hygeia, built in 1822 on Old Point Comfort next to Fort Monroe, was a very popular resort, but it was destroyed during the Civil War. Rebuilt when the conflict concluded, the Hygeia, named for the Greek goddess of health, was operated by Harrison Phoebus. Located near the Old Point Comfort Wharf and the C&O Railroad's Milepost 0, the Hygeia prospered as one of America's leading hotels. Its success prompted the construction of a second grand resort on Old Point Comfort, restaurateur and gambler John Chamberlin's The Chamberlin Hotel. Other hotels included the Sherwood Inn, the Kimberley, and Evans's Cottage. Opened in 1896, The Chamberlin was an immediate sensation. The popularity of Old Point Comfort as a resort destination inspired the town of Phoebus, across Mill Creek from Fort Monroe, to become home to four hotels and 52 saloons. Nearby Buckroe Beach became an attraction with a hotel, dancing pavilion, and amusement park. The only beach resort on the Peninsula for use by African American vacationers, Bay Shore Resort also opened in 1897. (Courtesy of Casemate Museum.)

By 1900, densely populated Newport News had become the center of business on the lower Peninsula. Washington Avenue became Newport News's business and entertainment focal point. Banks dotted the streetscape along with department stores, pharmacies, and other commercial ventures. Other community improvements were rapidly instituted. The city's first telephones were installed in 1898; the library association was formed in 1891. (Courtesy of NNPL.)

The rapidly growing port city also needed housing. The town was laid out in a grid pattern with numbered streets bisecting two major streets (then Washington and Virginia Avenues). Among the first houses built was a row of brick structures on Twenty-Eighth Street known as Quality Row, a contrast to nearby Poverty Row. West Avenue, facing the James River, was the desired address for the well-to-do. (Courtesy of NNPL.)

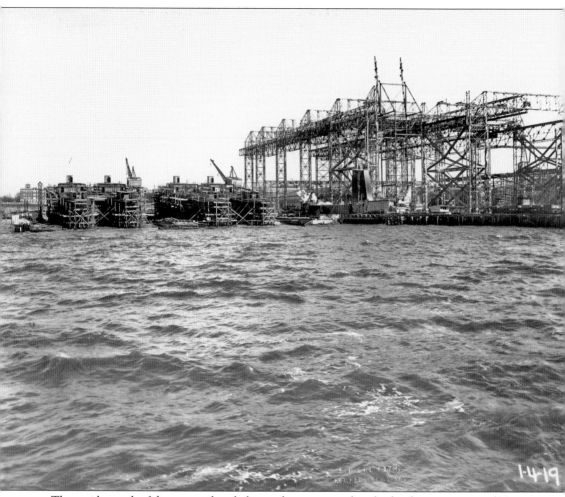

The rapid growth of the port, railroad, shipyard, tourism, and seafood industries prompted Newport News to incorporate as an independent city separate from Warwick County. Transportation and water systems became vastly important to the young city. Huntington's Old Dominion Land Company created the Newport News Light and Water Company. Gas was needed for lighting, and the Lee Hall Reservoir was created by damming the Warwick River. When C.P. Huntington died of a stroke on August 13, 1900, at Camp Pine Knot, Raquette Lake, New York, he left behind many accomplishments, such as the world's first transcontinental railway. His vision of Newport News laid the foundation for a modern city. He built a community, a port in touch with the world, a railroad connected to America's hinterland, and a shipyard determined to achieve success. Newport News had blossomed into a viable center of commerce, ready to assume its role in contributing to world peace. (Courtesy of TMMP.)

Two

World War I Comes to Hampton Roads

The assassination of Archduke Franz Ferdinand, heir to the throne of the Austro-Hungarian Empire, in Sarajevo on June 28, 1914, set the European nations on the road to war. Yet few foresaw at the onset that the war would last for years and millions would die in the gas and gloom of the endless muddy trenches. No one could envision that the autocratic world of Kaiser Wilhelm II or Tsar Nicholas II would be swept away—and in some cases replaced by Communist regimes. The conflict would not only change the map of Europe but would also profoundly change Newport News and would cause the creation, just three miles away from the bustling shipyard, of the first public planned community in America.

When World War I erupted in Europe, few took notice in Newport News. After all, the war was between European nations thousands of miles away, and few thought that the conflict would have any lasting impact on the world. In the first weeks of the war, the *Daily Press* kept everyone aware of the situation. Some became concerned about the events in Europe; others were concerned even more about staying out of the conflict. "While Europe is in the throes of war with famine staring many in the face, we have peace and plenty, and the smile of a beneficent Providence is upon us," the Thanksgiving Day editorial in the *Daily Press* observes. Nevertheless, as a seaport in touch with the world, Newport News was immediately brought into the conflict.

The war seemed far away, despite the internment of German freighters and commerce raiders in Hampton Roads. These ships piqued local interest, but it was the death of shipyard president Albert Hopkins, a passenger aboard the RMS *Lusitania*, sunk by a U-boat on May 7, 1915, that made the war a reality to Peninsula residents. When the United States entered the war two years later, Newport News was transformed into a boomtown.

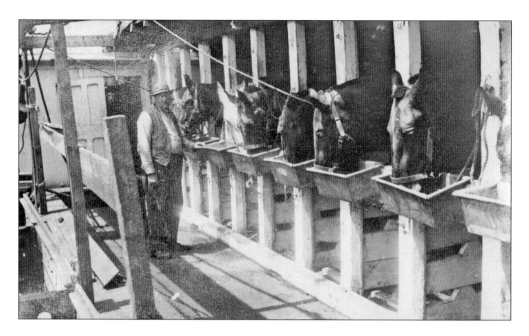

The average life of a horse on the western front was about 10 days. During World War I, horses were the primary means by which to transport cannons, men, and supplies to the front lines. Consequently, in November 1914, Capt. John Gregg established the British Remount Station in Newport News. Located between Thirtieth and Thirty-Fourth Streets, it was set up on land owned by Newport News businessman Philip Hiden. Hiden had made arrangements to build the entire complex of stalls, pens, bins, and pastures. During the last two months of 1914, the British Remount Station shipped more than 10,500 horses to Europe. By the war's end, Newport News had sent 437,000 animals, making the port the most important and biggest supplier of horses and mules for the British army. (Both, courtesy of Library of Virginia.)

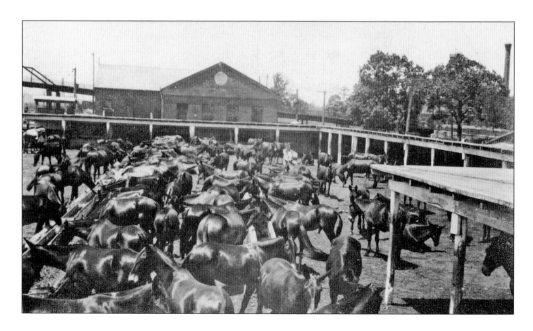

Glenn Hammond Curtiss was one of America's greatest early aviation pioneers. In 1907, Curtiss formed the Aerial Experimental Association with Alexander Graham Bell and began making airplanes. His most famous aircraft was the Curtiss Jenny. Curtiss selected a 20-acre site next to the Small Boat Harbor in Newport News to establish a flying school as well as to conduct seaplane experiments for the US Navy. (Courtesy of TMMP.)

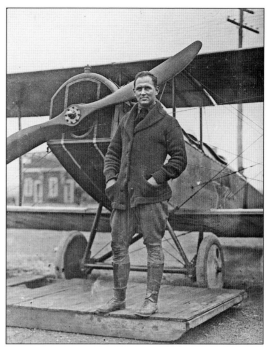

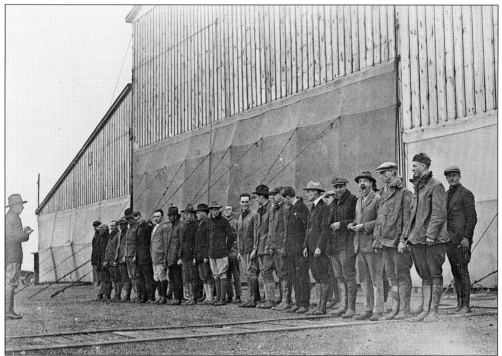

The school opened in 1915. Capt. Thomas Scott Baldwin, a balloonist who is also credited with making the first parachute jump, was placed in command. His instructors included noted aviators Eddie Stinson, Steven McGordon, and Victor Carlstrom. Stunts and training sometimes ended in disaster. Chief instructor Victor Carlstrom and photographer Gary B. Epes, a Newport News resident, were killed on May 9, 1917, during a training flight. (Courtesy of TMMP.)

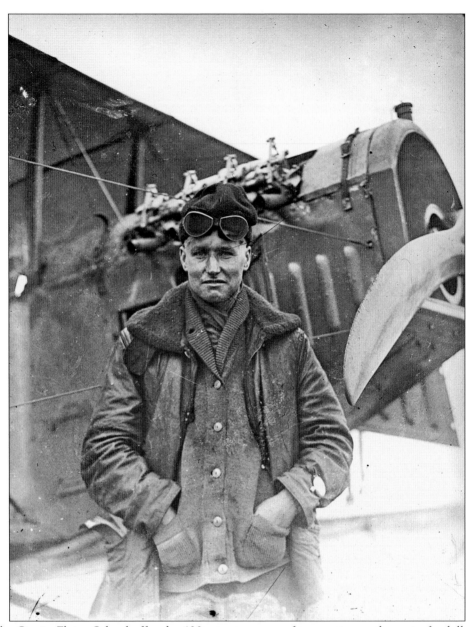

The Curtiss Flying School offered a 400-minute course of instruction at the cost of a dollar a minute. Once the course work and the training required by the Aero Club of America (ACA) were completed, one could apply for a coveted ACA license. In order to earn a certificate, according to student Louis Fielder, "You had to be able to fly three [figure] eights around two pylons." Some of the leading figures in American aviation, such as Col. Billy Mitchell, were associated with the school. Mitchell traveled by train each weekend from Washington, DC, to earn his wings. The first local graduate was H.M. "Buck" Gallop, who went on to become an ace in France. Legends persist that actor Richard Barthelmess modeled his character in the 1930 Oscar-winning film *The Dawn Patrol* on Gallop. Other famous students were Vernon Castle, the famous ballroom dancer, who traveled weekly from New York to attend classes; and Geoffrey O'Hara, the composer of the popular ragtime hit "K-K-K-Katy." (Courtesy of TMMP.)

Excitement arose in Newport News when the German commerce raider *Prinz Eitel Friedrich* ran past British cruiser patrols and docked at the shipyard for repairs. The ship had traveled more than 20,000 miles during a seven-month cruise and had sunk 11 merchant ships. The ship's arrival created a sensation, and curiosity-seekers from throughout the East Coast traveled to Newport News to glimpse the famous "ghost ship." (Courtesy of LOC.)

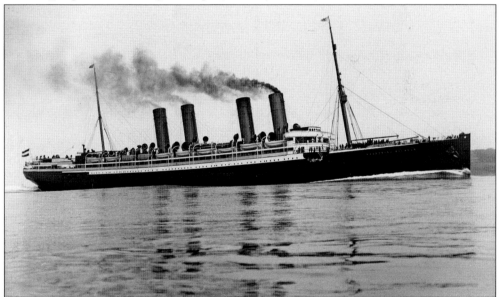

Just two days later, another German commerce raider, the *Kronprinz Wilhelm*, arrived at Newport News. It sank 14 merchant ships during its daring cruise across the Atlantic. Both these ships required too many repairs and were interned at the Norfolk Navy Yard. When the United States entered World War I, the raiders were renamed USS *De Kalb* and USS *Von Steuben* and turned into American troop ships. (Courtesy of TMMP.)

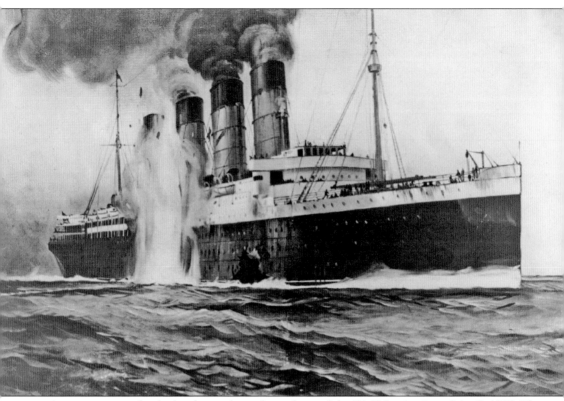

Americans were shocked to learn about the sinking of the RMS *Lusitania* on May 7, 1915. The liner was sunk by one torpedo from the German submarine *U-20*. The torpedo struck the *Lusitania* on the starboard bow, just below the wheelhouse. Moments later, a second, more horrific and loud explosion came out of the liner's hull. The vessel sank in 18 minutes. Of the 1,959 passengers and crew, 1,195 lost their lives; 764 survived the disaster. Americans were outraged by the ship's sinking. The *Lusitania* carried 139 US citizens; sadly, 128 lost their lives. Many notable Americans were aboard and died, including Arthur Henry Davis, president of the United States Rubber Company and chemist Ann Justice Shymer, president of the United Stated Chemical Company. In his animated 1918 propaganda film, *Sinking of the Lusitania*, Winsor McKay notes several other Americans perished, among them playwright Charles Klein, philosopher and author Elbert Hubbard, and sportsman Alfred Gwynne Vanderbilt. It was said Vanderbilt was last seen fastening a life vest onto a woman holding a baby. The one death that truly brought this disaster and the "Great War" close to home in Newport News was that of Albert Lloyd Hopkins. The 42-year-old Hopkins was the president of Newport News Shipbuilding and Dry Dock Company. He had been traveling to Great Britain to negotiate fabricating armor plates for warships. The yard closed for a half day in his honor. (George Grantham Bain Collection, courtesy of LOC.)

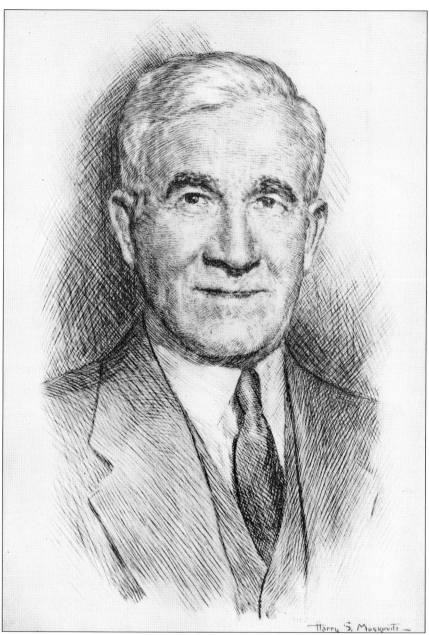

Homer Lenoir Ferguson assumed the yard's presidency on July 22, 1915. A North Carolina native, he graduated from the US Naval Academy in 1892. He was then selected to attend the School of Naval Architecture and Marine Engineering at the University of Glasgow in Scotland. After three years of post-graduate work, Ferguson was appointed an assistant naval constructor. He resigned from the US Navy in 1904 and was assigned to work at Newport News Shipbuilding as assistant superintendent of hull construction with a salary of $5,000 per year. He was promoted to general superintendent in 1911 and assumed the position of general manager. Ferguson began making improvements, preparing the yard in the eventuality of America joining the war. In January 1916, $400,000 in plant improvements were allocated. By 1917, seven thousand workers were employed. This number would increase to 12,500 by 1919. (Courtesy of TMMP.)

The realization of military aviation's importance prompted Congress to establish the National Advisory Committee for Aeronautics (NACA) on March 3, 1915. The Army Appropriations Act provided funds to build a major aviation and experimental base in the Chesapeake region, and a site on the Back River was purchased on December 5, 1916. Named in honor of aviation pioneer Samuel Pierpont Langley, Langley Field was just what NACA wanted—it was near an existing military installation with excellent transportation connections and was located in a temperate climate. Yet construction was delayed because the Back River marshlands selected for the airfield had, as one of the workers noted, "the muddiest mud, the weediest weeds, the dustiest dust and the most ferocious mosquitoes the world had ever known." Despite construction difficulties throughout 1917, Langley Field became operational with the establishment of the 119th Aero Squadron, Detachment 11, Air Service, Air Production. This was the only detachment assigned to evaluate American and foreign aircraft—planes such as the Albree Monoplane, the Thomas Morse S-4 Scout, the Macchi M-5 Flying Boat, the Bristol Fighter, and the Caproni CA-33. The US Army School of Aerial Photography was also established there in March 1918. Another school established at Langley Field was the School of Aerial Photographic Reconnaissance, later designated the Air Service Flying School. (Courtesy of LOC.)

The new town of Penniman, named for Russell S. Penniman, the inventor of ammonia dynamite, was established near Williamsburg in York County. Developed by the E.I. duPont de Nemours Company, one of the world's greatest producers of gunpowder/gun cotton and ammunition, it was sited along the York River between Queens and King Creeks, six miles from Williamsburg. The site was chosen because dynamite and high-explosive shells were very hazardous to produce; most munition factories were in isolated places. DuPont, of Wilmington, Delaware, required the new plant to meet the Allied demand for high-explosive artillery shells. Plant No. 37, as Penniman was known, would become one of the largest shell-producing plants in America, capable of manufacturing twenty-seven thousand 75-millimeter and 155-millimeter caliber shells per day. These high-explosive shells were loaded at the plant and sent by rail to Newport News, where they were shipped to Europe. The industrial village of Penniman would become home to more than 10,000 workers; it had its own churches, restaurants, post office, hotel, hospital, YMCA, school, and police force. The entire project required more than 5,000 laborers and carpenters to work overtime building apartments, dormitories, cottages, and houses. The village was so large that every day, the Penniman Post Office handled 12,000 to 14,0000 letters and 75 to 100 sacks of parcels. The plant was closed when the war ended, and the property was acquired by the US Navy. (Courtesy of LOC.)

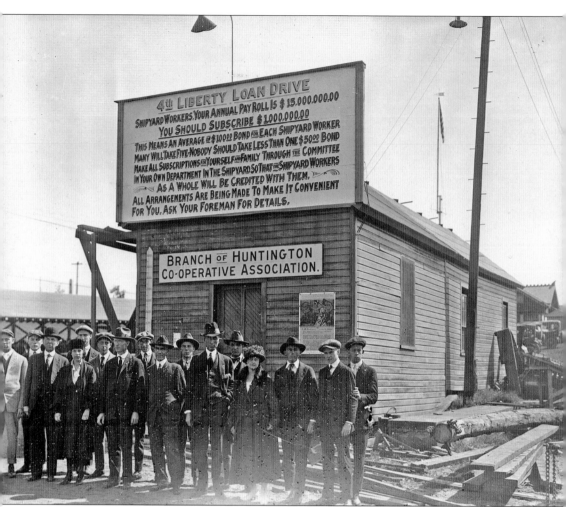

Even before the United States entered the Great War, the shipyard had built or repaired 150 merchant ships. Pres. Woodrow Wilson established the US Shipping Board and its subsidiary, the Emergency Fleet Corporation. In addition to the expansion of merchant ship production, Congress enacted an aggressive shipbuilding program. The Newport News yard was already constructing the dreadnoughts USS *Pennsylvania* and *Mississippi* and had received contracts to build two battleships, the *Maryland* and *West Virginia*, as well as two battle cruisers. Once America entered the war, the yard received more than $100 million in contracts and resorted to a round-the-clock production schedule to complete the rush orders. To keep workers' morale up, Ferguson established the Newport News Shipyard Band, directed by Walter Kepper. It gave noontime concerts on Tuesdays and Fridays, and it was reported that "music hath pep to help us whip the Kaiser." The shipyard's newsletter, *Rivets* (later renamed the *Shipbuilder*), was first published in 1918 and provided workers with patriotic spirit, featuring slogans such as "If U Work U Beat U Boats," and "Come, let us warship." (Courtesy of NNPL.)

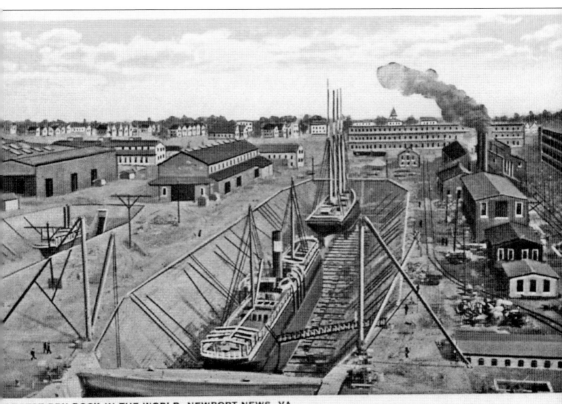

LARGEST DRY DOCK IN THE WORLD, NEWPORT NEWS, VA.

The Emergency Fleet Corporation requested that the shipyard build primarily combat ships, particularly destroyers, during the war. The yard constructed 10 merchant ships for the Emergency Fleet Corporation as well as 137 merchant ships for private owners. Repair work constituted the majority of the shipyard's activities during the war, including 144 transports and other smaller vessels for the US Army, 118 for the US Navy, 160 for the British government, and 437 for private owners. In total, 1,000 ships were repaired. The shipyard's endless need for workers resulted in the employment of women; most worked on merchant ship repair and construction. Extra workers, including novelist Thomas Wolfe, were needed for every kind of task. Employed at the shipyard during the summer while attending the University of North Carolina at Chapel Hill, Wolfe later wrote in his seminal work, *Look Homeward Angel*, "There were strange rumors of a land of El Dorado to the north, amid the world war industry of the Virginia coast. . . . One could earn twelve dollars a day, with no experience. . . . No questions were asked." Virginius Dabney, a 1948 Pulitzer Prize–winning Richmond, Virginia, newspaper editor and historian, worked at the shipyard as a bolter in the fitters' department during his summer break from the University of Virginia. Dabney remembered one August day in 1918 when it got so hot that "the shipyard had to shut down for an entire day. . . . It was 110 in the shade and this was made far worse by the hot sun on the metal decks, not to mention the stoves with red hot rivets." (Courtesy of NNPL.)

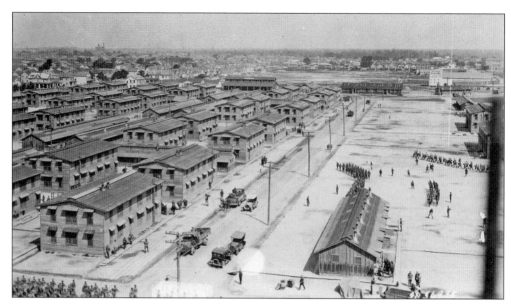

Newport News was selected as the headquarters of the Hampton Roads Port of Embarkation in July 1917. The city offered everything that was needed: good port facilities, a large harbor, excellent railroad connections, and an abundance of available land. The US Army quickly assumed operations of the C&O Railway and established its headquarters at the Post Office and Customs House in downtown Newport News. Col. (later Brig. Gen.) Grote Hutchinson was port commander. Thomas Wolfe wrote about the endless movement of troops, noting: "Twice a week the troops went through. They stood densely in brown and weary, thousands on the pier. . . . Then, each below the sweating torture of his pack, they were filed from the hot furnace of the pier into the hotter prison of the ship. The great ships, with their motley jagged patches of deception, waited in the stream; they slid in and out in unending squadrons." In April 1918, a total of 46,130 men left Newport News aboard 31 vessels bound for Europe. (Both, courtesy of Virginia Peninsula Chamber of Commerce.)

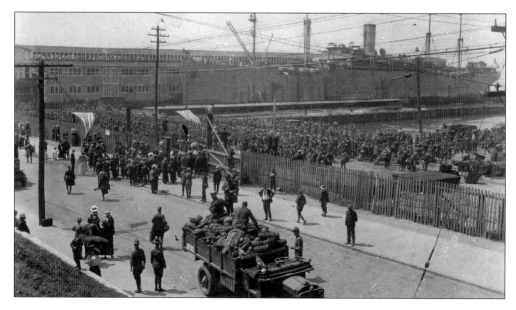

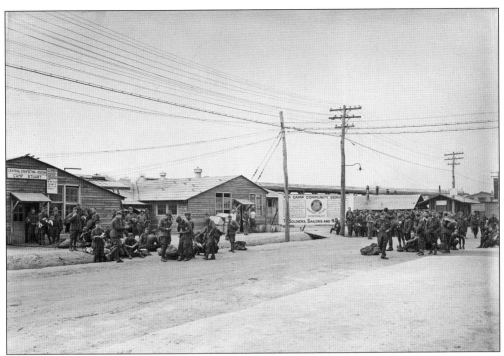

The Army rapidly began to acquire large tracts of property in Warwick County for troop staging areas. Four major camps were established. Camp Stuart, named for the Confederate general J.E.B. Stuart, was the largest embarkation camp in the United States and was located between the Small Boat Harbor and Salters Creek. It processed 115,000 soldiers en route to France. Camp Hill was located in Warwick County along the James River and was named in honor of Confederate general A.P. Hill. In addition to processing 67,887 men overseas, it served as the port's animal embarkation area. The camp's capacity was 10,000 animals. A total of 33,704 horses and 24,474 mules were handled by Camp Hill. Camp Alexander, named for Lt. John Hanks Alexander, one of the first African Americans to graduate from West Point, processed black labor battalions. (Above, courtesy of TMMP; below, courtesy of Library of Virginia.)

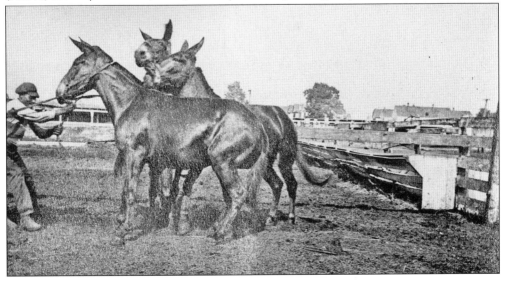

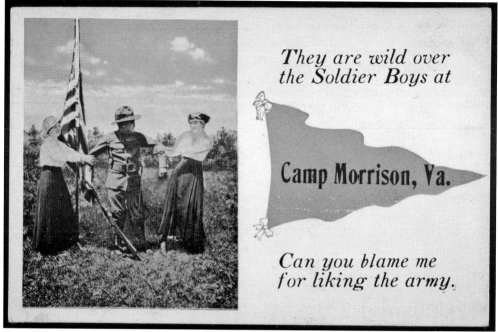

They are wild over the Soldier Boys at

Camp Morrison, Va.

Can you blame me for liking the army.

Camp Morrison was an air service depot organized along the C&O tracks in the Gum Grove section of Warwick County. The 295-acre site, named for Col. J.S. Morrison, served as the embarkation center for balloon units and aero squadrons. More than 100,000 men were processed there, and the camp included 24 warehouses built for the storage of aviation equipment and supplies. The Army decided to establish a larger artillery base on Mulberry Island in Warwick County. The construction of Camp Eustis began on April 28, 1918, and the camp became the concentration point for heavy artillery units. More than 20,000 men passed through the camp. Several schools were established, providing training in mortars, motor transport, antiaircraft, and railway artillery. The marshes were perfect for firing heavy artillery; some exercises were completed under simulated combat conditions. (Above, courtesy of John Lash; below, courtesy of US Army.)

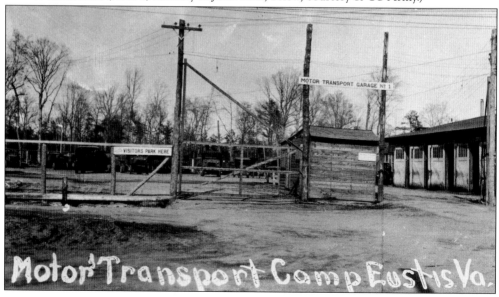

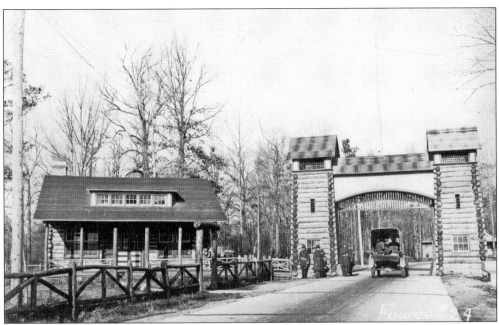

Observation balloons were considered a useful method of gathering tactical information during World War I. The Army accordingly established the Lee Hall Balloon School at Camp Eustis in 1918. The mission of the US Air Service Balloon Section was to regulate artillery fire, locate targets, and report all activity within the enemy lines. The school focused on artillery observation work as well as the operation of balloon winches, telephone line work, machine-gunnery, and radio observation. The Lee Hall Balloon School became one of the largest balloon training facilities in the country. The typical US Army gas balloon was designed with a gondola at the balloon's stern to carry two men to the height of about 2,000 feet. Balloons were attached to the ground by cables, and if attacked, they could be quickly winched back to the ground. This design and system enabled balloons to improve an important battlefield link between forward observation intelligence and artillery. (Both, courtesy of US Army.)

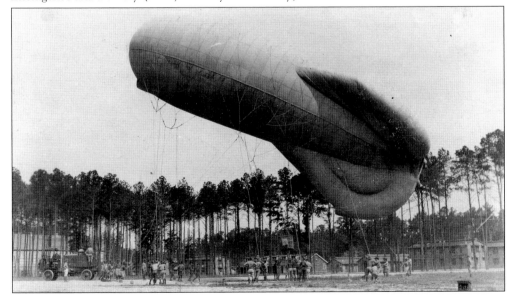

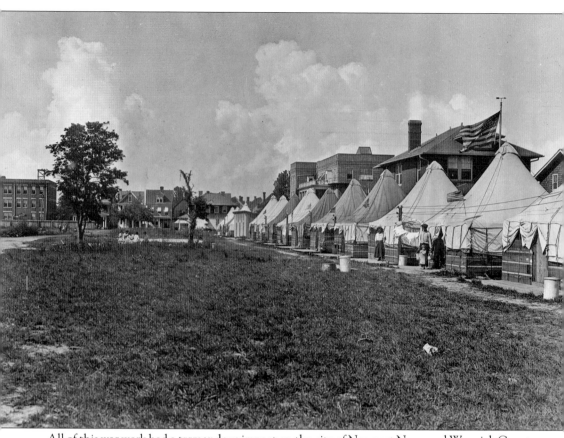

All of this war work had a tremendous impact on the city of Newport News and Warwick County. Between 1910 and 1920, Newport News nearly doubled in population, rising from 26,246 to 47,013. The latter number did not account for the peak population of transient and contract war workers. A serious housing shortage plagued every aspect of Newport News's role in war work. The housing situation also created the chance for those who had rooms to rent to become involved. Boardinghouses were filled to overflowing, and casual laborers resorted to the practice of "hot bedding," or room sharing. This shortage limited access to skilled workers, and efforts to construct temporary barracks and tent colonies did not solve the problem. This led the energetic and enterprising Homer Ferguson to develop a viable plan that would have an everlasting impact on the city of Newport News. (Courtesy of TMMP.)

Three

THE SHIPYARD
HOUSING CRISIS

In 1917, the production capacity of Newport News Shipbuilding and Dry Dock Company could not reach its potential due to an inadequate labor supply. The lack of family housing and overcrowded conditions reduced the shipyard's ability to fill war contracts. It became very clear to both the US government and the shipyard that action must be taken to address this critical housing shortage.

Shipyard president Homer Ferguson recognized that better housing was needed to attract and retain skilled workers. Ferguson advanced $50,000 of shipyard funds to Huntington-owned Old Dominion Land Company to build 75 homes along Virginia Avenue for workers. This was not enough. Accordingly, in October 1917, the shipyard contracted noted landscape architect Henry Vincent Hubbard, architect Francis Johannes, and sanitation engineer Frances H. Bulot to develop an independent community for shipyard workers.

The creation of this distinguished team was a "distinct innovation . . . which was later hailed as an outstanding innovation to the new city-planning movement." Hubbard further asserted that the cooperation of architect, engineer, and town planner is "an ideal one, reflecting as it does the three great requirements of any such development: beauty and utility of houses and public buildings; adaptation of public utilities, to local conditions, and to consideration of economy; and beauty of grounds and adaptation to topography and to life and growth of the community."

This village concept was representative of how the town planning movement in the United States was evolving. Hubbard believed that "temporary housing, after the war, is little better than scrap," and he sought to make his new shipyard community, built two miles away from the shipyard itself, a prime example of the Garden City movement. Hilton Village would eventually become the first and most successful example of this new approach in community planning, underwritten by the federal government. The entire project was a distinct and harmonious town creation endeavor.

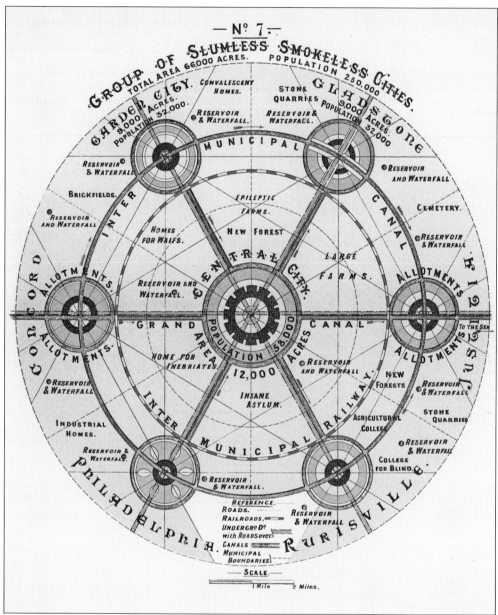

Henry Vincent Hubbard, a student of Frederick Law Olmsted Jr. and a Harvard professor, was well aware of the new theoretical concepts of town planning as expressed in Sir Ebenezer Howard's 1902 volume, *Garden Cities of Tomorrow*. Howard developed his utopian Garden City concepts and Fabian socialist ideas, ones he shared with H.G. Wells. Howard believed that inhumane assembly line conditions associated with industrialization were responsible for social ills and city deterioration. He proposed that garden cities would ameliorate the urban problems of poverty, poorly ventilated houses, dust, toxic substances, carbon gases, infectious diseases, and the lack of interaction with nature by creating towns away from the factories, replete with opportunity, amusement, beauty, and fresh air. Howard envisioned a planned town being the blend of town and country, linked by effective transportation systems but protected by a belt of countryside. (Courtesy of John V. Quarstein.)

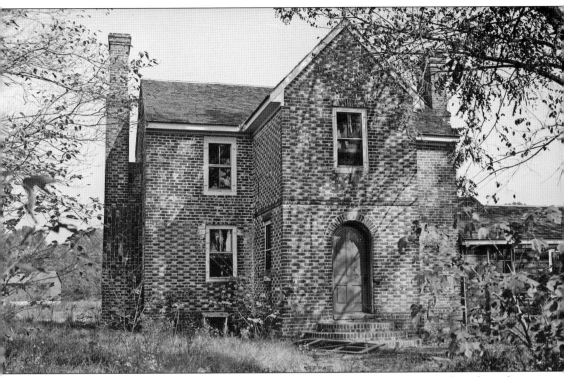

Howard founded the Garden City Association in 1899 to create the garden city of Letchworth, England. Raymond Unwin and Barry Parker were the architects. Unwin asserted that effective town planning could ensure residents' well-being. The planned community was a utopian socialist concept that strove to create a better life for all. Unwin also believed that the planner's role was "to guide and control the activities of a community by bringing order and a sense of design to the working of society." Unwin also thought that "aesthetic quality and well-constructed building could also be economical." Howard and Unwin believed in the sense of community living, based on the idea of an English village with its "English cottage traditions, and the concepts of harmony and unity." This was achieved by using high-sloping roofs, dormers, and large central gables. Unwin clustered cottages into two- or four-family houses creating a distinctive look: harmony and symmetry without sameness. The Tudor, Georgian, and Dutch Revival architectural styles coupled with the fresh and interactive planning concepts made Hilton Village the place to build the first public planned community. The English cottage designs reminded many of their European heritage. After all, when the first colonists arrived at Jamestown, they wished to re-create their homeland in the New World. Tudor/Jacobean colonial structures such as St. Luke's Church in Isle of Wight County, Bacon's Castle in Surry County, and the Matthew Jones House (seen here) on Mulberry Island within Fort Eustis, Newport News, Virginia, are visible connections to Hilton Village's unique architecture. (Courtesy of LOC.)

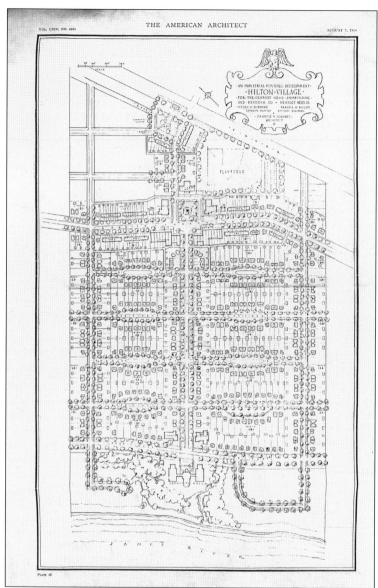

THE AMERICAN ARCHITECT
VOL. CXIV, NO. 2224
AUGUST 7, 1918

Hubbard and Joannes wove all of these thoughts, concepts, and designs into their Hilton Village masterpiece. Even though Hilton's houses seem to have been taken from an old English village, the community featured the most modern systems of sanitation engineering, storm water management, and electricity. The homes were extremely well built despite being very economical to construct. Hilton was to be its own community with schools, shops, and churches all laid out with the belief that a worker's efficiency increases when his living conditions are improved. Hilton, with all of its modern attributes, was steeped in the past and as such was a model for future developments. Once Hubbard's concept was approved, planning was initiated on December 24, 1917. The shipyard optioned a property known as the Darling Tract: approximately 200 acres located two miles north of the shipyard astride the Warwick County Road, abutted by the C&O tracks to the east and the James River to the west. (Courtesy of City of Newport News.)

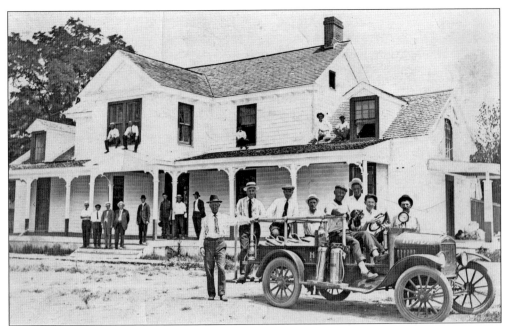

The only house on this tract was originally owned by naval officer Lt. John Pembroke Jones (right) and his first wife, June Vance London, of North Carolina. She named the house Hilton; it eventually was home to the Hilton Village Fire Department Clubhouse. Jones had served in both the Union and Confederate navies; he was the flag lieutenant of the CSS *Virginia* (*Merrimack*) when the Confederate ironclad was scuttled off of Craney Island on May 11, 1862. Even though the Darling Tract was a heavily wooded parcel, it was selected for two primary reasons: the land's level topography would reduce development costs and problems, and the site was considered to be the best available, as it was near the shipyard and accessible via the extension of the existing trolley service. (Above, courtesy of NNPL; right, courtesy of the 290 Foundation.)

45

On January 9, 1918, Homer Ferguson (left) appeared before the US Senate as the star witness of the Senate subcommittee (including Warren Harding, following image) that was reviewing shipbuilding, industrial housing, and the war effort. Ferguson stated that housing conditions in Newport News were wretched, and he called for immediate action by the government. He noted that the shipyard had already created a preliminary plan for a village of 500 houses. The shipyard president offered to purchase the land if the government would finance the project's construction. Ferguson concluded that he could not employee enough men to fill a single shift, even though he knew the yard should be operating day and night to produce the ships needed. Consequently, the US government agreed to support the shipbuilder's related public housing projects. (Courtesy of TMMP.)

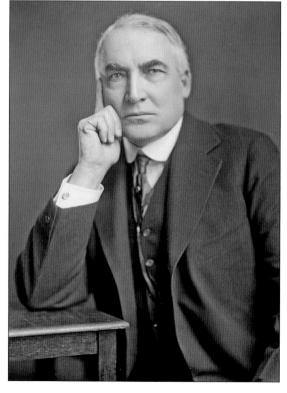

The US Senate approved funds for the Hilton Village project via the US Shipping Board, created in 1916 to expand America's merchant fleet. The board's work was much expanded when America entered World War I. Edward N. Hurley served as the board's chairman. On April 16, 1917, the Emergency Fleet Corporation was established to acquire, maintain, and operate merchant vessels under certain conditions and to transfer ships to private companies when feasible. Eventually, the EFC was managed by Director General Charles M. Schwab with Charles Piez serving as vice president/general manager. (Harris & Ewing Collection, courtesy of LOC.)

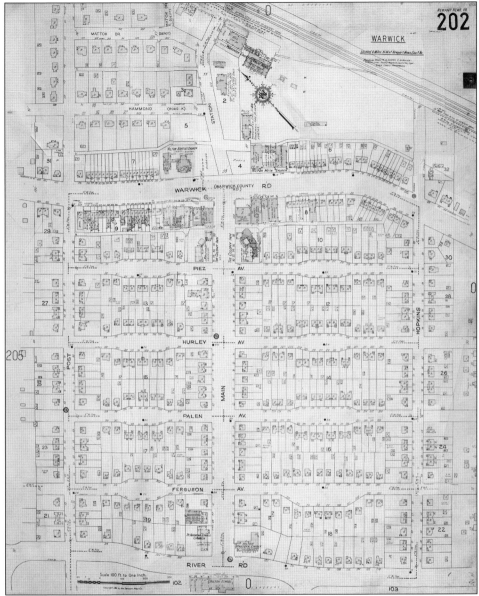

Hubbard's concept for Hilton was a modified gridiron based on a main access from the town square on Warwick County Road to the community center on a little hill, bordered by a small brook and overlooking the James River. The streets ran parallel to the shore, some carrying through to future developments, some being dead-ended. Hilton Village was designed for shipyard workers, and each street name had a connection to the yard. Hopkins Street was named for Albert Hopkins, a former yard president. He was replaced by Homer L. Ferguson; Ferguson Avenue was named for the shipyard president who insisted on the construction of Hilton Village. Post Street was named in honor of Ferguson's mentor, Walter A. Post, who was associated with Collis P. Huntington from the very beginning of Newport News. Palen Avenue was named for shipyard vice president Frederick Palen; Hurley Avenue was named for US Shipping Board president Edward H. Hurley; and Piez Avenue was named in honor of the Emergency Fleet Corporation's vice president, Charles Piez. (Courtesy of the City of Newport News.)

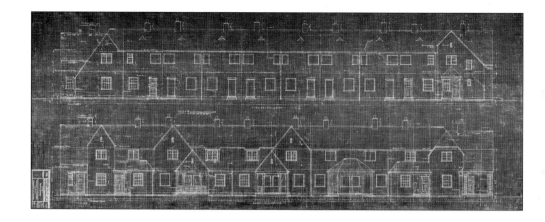

The landscape architect connected the housing with a railroad station that featured its own square. Hilton included parks and playgrounds with footage on the James River. Hubbard made lots varying in size from 118 feet to 130 feet deep. He kept the cross streets narrow to limit traffic. Main Street, the major thoroughfare, is the widest in the village at 100 feet. The roadways that ran parallel to River Road were 50 feet wide. The houses in the middle of these long blocks were set back to allow for an island in the middle of the road for use as common space. Four church sites were set aside as were room for a school and community center on the James River. Hubbard also designed lots around the borders of the village, as he knew that the success of the development would eventually result in people wanting to build their own homes, especially overlooking the water. These lots were, Hubbard said, "held to be used for homes by those who can afford to spend more than the average." (Both, courtesy of Library of Virginia.)

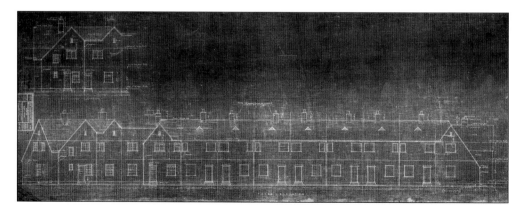

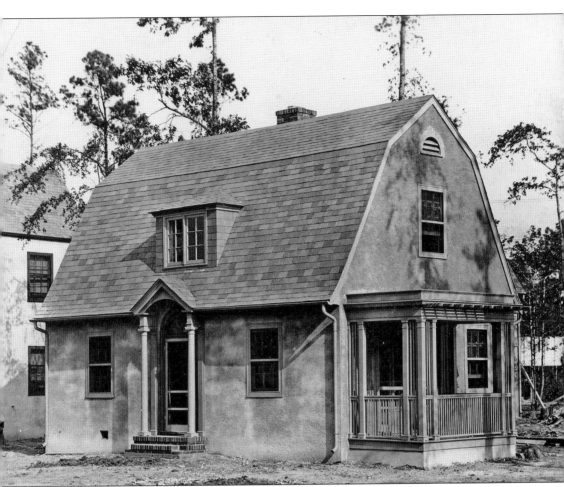

Once Hubbard finished his village layout, Francis Joannes set about to design the structures based on input the team had received from shipyard workers and their wives, the salary study to determine affordability, and a construction cost survey. The exterior designs assumed an English cottage look. Design elements—the steeply pitched slate roofs featuring hipped, gambrel, clipped gambrel, and gable styles; casement windows; chimneys with chimney pots; rounded, arched doorways; and the overall simplicity—joined together to reinforce the English influence. Joannes created 14 major designs using Jacobean, Dutch Colonial Revival, Tudor Revival, and Georgian Colonial Revival styles. Hilton's architectural variations were extremely well conceived. The innovative house designs and town layout as devised by the dynamic duo of Joannes and Hubbard made the village unique amongst all other World War I planned public housing projects. Hubbard had stressed that wartime housing should not be temporary but of a permanent construction, layout, and design so that it would be a lasting contribution to the community. (Courtesy of NNPL.)

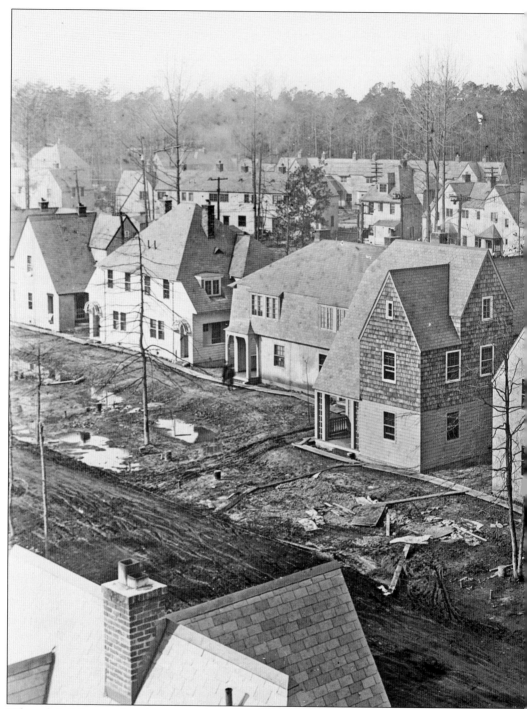

Hilton defied the tract housing approach used in so many other developments thanks to Joannes's combinations and recombinations of design elements, allowing the architect to achieve a variety of house relationships to one another. This manipulation of the position of the entryways, walkways, and driveways avoided a repetitive streetscape and gave the viewer's eye more of a syncopated rhythm of sight. "One house," according to architect Susan C. Perkins, "has a centrally placed

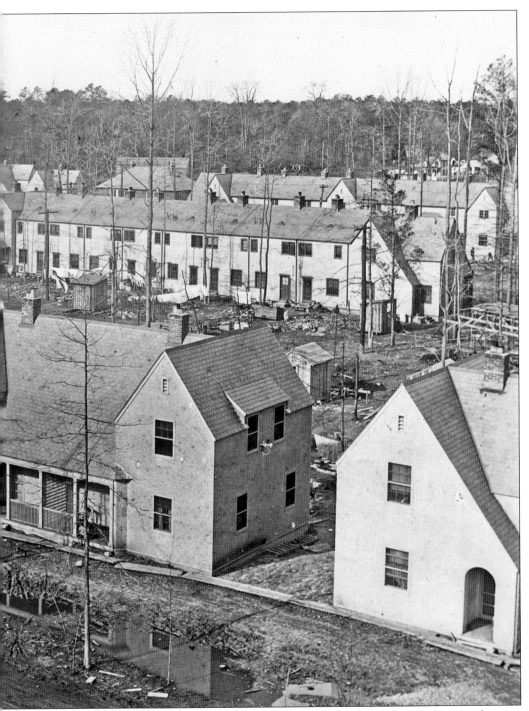

entry, another is offset to the right or left. Still others incorporate a shift in direction because the entry is on the side . . . the fact that exists not one standard relationship; but, instead many, gives the block and street visual texture." The integration of duplexes into the streetscape further enhanced the overall English look. (Courtesy of NNPL.)

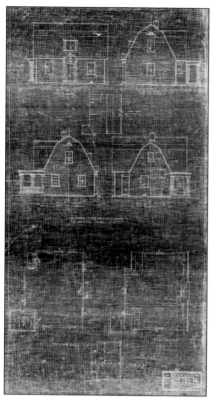

Joannes added further flair by varying the basic designs from one-and-a-half to two-and-a-half stories when feasible. The different house types were scattered throughout the village. As all homes were wood-frame construction, additional design alternatives were achieved by varied sheathing of stucco, shingles, or clapboards. What also made the use of just over a dozen designs work so well for a planned 500-house community was how Joannes turned designs on various-sized lots to provide different looks and yard depths. No single street had similar houses, although the same basic designs were continually used. (Left, courtesy of Library of Virginia; below, courtesy of NNPL.)

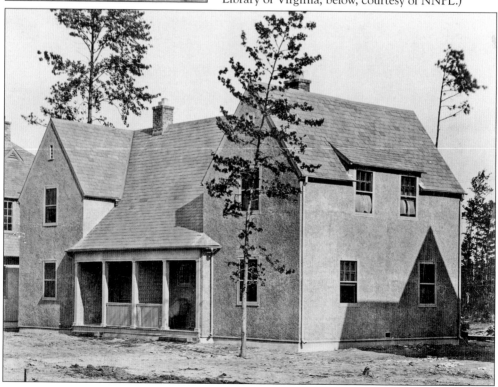

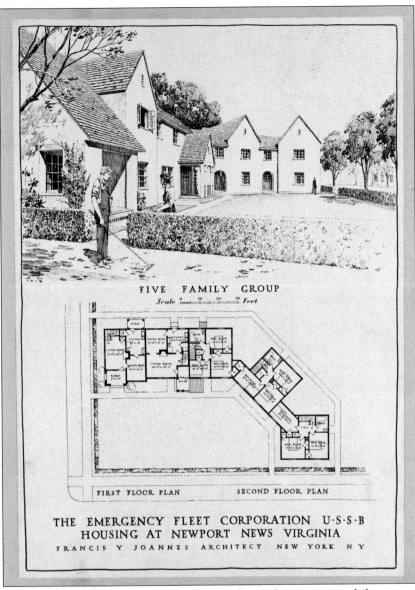

FIVE FAMILY GROUP

Scale 0 10 20 30 Feet

FIRST FLOOR PLAN SECOND FLOOR PLAN

THE EMERGENCY FLEET CORPORATION U·S·S·B
HOUSING AT NEWPORT NEWS VIRGINIA

FRANCIS Y JOANNES ARCHITECT NEW YORK N Y

Joannes found it interesting to create "double houses" by combining two single houses on one lot. Since he believed that eastern Virginia had mild winters, he did not incorporate cellars or space for heating systems. This was a major flaw that impacted his duplex design, and he was required to have a central chimney for each half of a duplex structure. The third-floor stacked-design duplexes and the stairway returning into itself to serve each floor not only used space economically, it also sent heat to the upper floors. The central fireplace warmed its surrounding walls. Joannes was able to combine houses back-to-back as well as side-to-side, offering unique exteriors that enhance the streetscape. The duplexes were often located in the center of a block or set back even further than other houses to create a parklike atmosphere with wider green space. Hubbard's layout enabled the architect to place a maximum number of dwellings without exceeding the choice population per acre. (Courtesy of Harvard Art Museums/Fogg Museum, Transfer from the Carpenter Center for the Visual Arts, Social Museum Collection. Photo: Imaging Department © President and Fellows of Harvard College.)

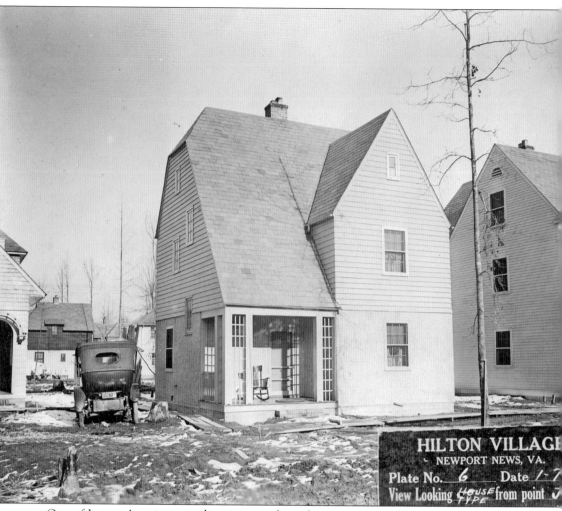

One of Joannes's major considerations was how the type, size, and locations interacted with the lot sizes. He wished to avoid the pillbox effect of a large group of small houses. One of his solutions integrated a number of two-family homes placed at specific intervals on the blocks. This solidified the appearance of the community as a whole. Nevertheless, he knew homeowners needed outbuildings to store coal, wood, garden tools, and other supplies. Consequently, Joannes designed outbuildings large enough to house a small car. In an effort to improve the general appearance, the architect endeavored to combine the structures wherever he could into twos, threes, and fours. These outbuildings were set back on the lots to the sides of houses to maintain streetscape symmetry. (Courtesy of NNPL.)

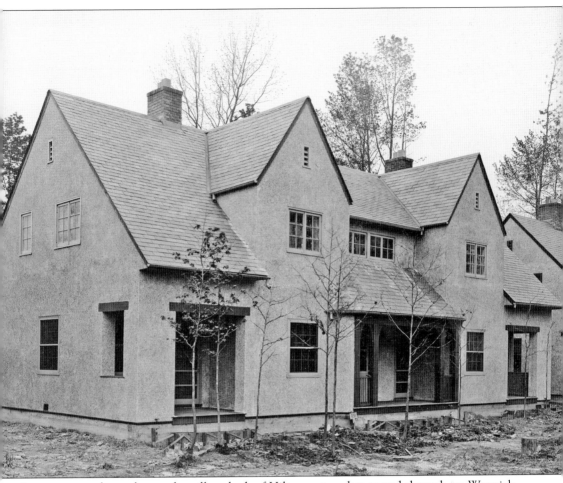

Joannes wanted to enhance the village look of Hilton as travelers passed through on Warwick County Road. He designed a row of terrace-type homes along the highway that were ideal for apprentices or young married couples with few or no children. These row houses each had four rooms featuring a combination of kitchen and dining room, living room, two bedrooms, and a bath. The end houses of each row concluded the enhanced architectural appearance of the village with five- and six-room houses. At the village square, Joannes designed 20 stores with small apartments on the second story. This design feature fostered local business growth and gave Hilton multiclass living accommodations as a shipyard worker community. (Courtesy of NNPL.)

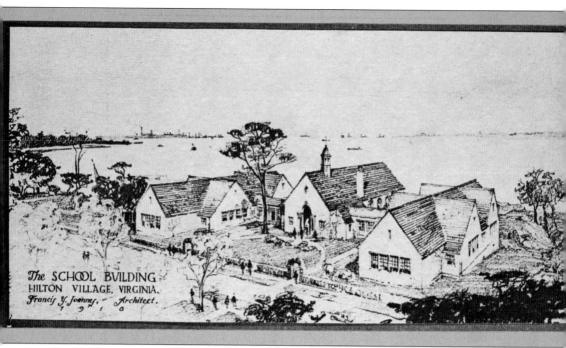

The SCHOOL BUILDING
HILTON VILLAGE, VIRGINIA.
Francis Y. Joannes. — Architect.

Besides the two church lots, Joannes made provisions in store groupings for "a moving picture theater, billiard hall, and bowling alley," as well as public meeting space. He also completed a design for the proposed school, located on the James River, that was to be combined with "a meeting room, gymnasium, domestic science room, and other community features." The school was flanked by two small parks. Across River Road were two church lots. Hubbard had envisioned the River Road square to be a gateway for residents to learn through school and other community features. Access to the James River via the two parks provided a calming atmosphere for the residents. River Road was conceived as a pleasure drive. Consequently, all of the key elements of the Garden City movement—walking distance to a commercial area, a restful streetscape, unique architecture with modern amenities, and a sense of relaxation and fulfillment by residents—were achieved as they walked the sidewalks, enjoyed the parks, and were calmed by the James River. An often overlooked Hilton Village planning and construction process is the rainwater and sewerage systems designed by the noted engineer Francis Bulot. Bulot, a graduate of the University of Illinois and University of Chicago, had gained an outstanding reputation with his engineering work on Shawnee Park, Fort Wayne, Indiana, in 1916. His concise approach to municipal sanitation was a major asset for Hilton Village. (Courtesy of Harvard Art Museums/Fogg Museum, Transfer from the Carpenter Center for the Visual Arts, Social Museum Collection. Photo: Imaging Department © President and Fellows of Harvard College.)

Four

A VILLAGE IS BORN

The Hilton Village team of Hubbard, Joannes, and Bulot finished their designs by early February 1918. As conceived, Hilton Village was an extremely new venture in government-funded housing, town planning, wastewater management, and house design. Hilton was a very forward-thinking housing development based upon Sir Ebenezer Howard's Garden City movement as implemented by architect Raymond Unwin in the construction of the garden city of Letchworth, England. Howard's concept had already been utilized in the creation of the privately funded Forest Hills Gardens in New York by town planner Frederick Law Olmsted Jr. and architect Grosvenor Atterbury. Hubbard and Joannes developed the new model town of Hilton Village, bridging the future with the past.

In many ways, Hilton harkened back to Colonial Virginia, as colonists strove to re-create England in the American wilderness. Colonial structures like Bacon's Castle in Surry County, St. Luke's Church in Isle of Wight County, and the Matthew Jones house on Mulberry Island (Fort Eustis) in Newport News all have architectural connections to Hilton as reflected by the Tudor and Jacobean styles found throughout the village.

Homer Ferguson not only was able to secure federal backing for his emergency housing for shipyard workers but his selection of the Hubbard-Joannes team ensured that it would be a permanent community. Henry Vincent Hubbard was an internationally known landscape architect from Harvard University, where he studied under Frederick Law Olmsted Jr. After work in private practice, Hubbard returned to teach at Harvard in 1917. He and his wife, Theodora Kimball Hubbard, wrote *An Introduction to the Study of Landscape Design*, which became the standard textbook for landscape architecture. Hubbard's accomplishments enabled him to plan a distinct new village. Equally eminent was architect Francis Joannes, who studied at the School of the Art Institute of Chicago, Cornell University, and École des Beaux-Arts in Paris. He was most noted for his design of the Department of Justice building in Washington, DC. These leaders joined their talents to underwrite, plan, and design a unique community that would rise from the Warwick County wilderness during the forthcoming years.

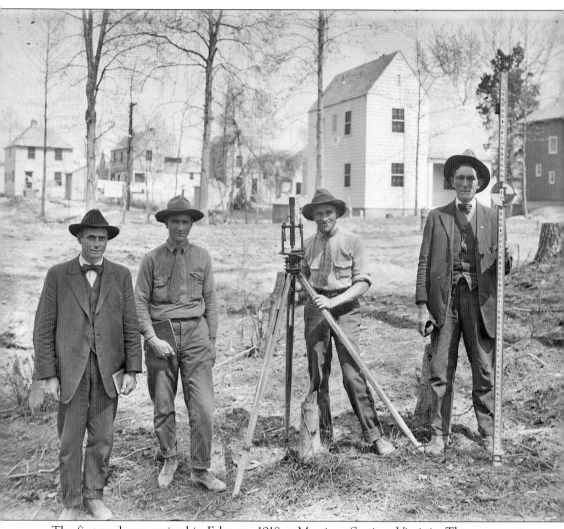

The first workmen arrived in February 1918 at Morrison Station, Virginia. The surveyor team had to lay out streets, sewer lines, lots, and storm water drains. As the surveyors worked, the Mellon-Stuart Construction Company of Pittsburgh, Pennsylvania, was engaged as the general contractor. The company was founded on December 31, 1917, by Thomas W. Mellon, who was embarking upon a career outside of his family's banking business. (Courtesy of TMMP.)

Eventually, the Mellon-Stuart Company would employ more than 1,700 workers. Skilled workmen were paid between $80 and $90 per week. Despite these excellent wages, Mellon-Stuart had some difficulty maintaining its workforce. The *Daily Press* reported that the labor problems were because "many of the men were floaters who remained only long enough to get a stake [just a few paychecks], then they would leave." The labor issues were mainly due to the vast amount of war-related government building projects that were ongoing by early 1918. Thousands of workers were urgently needed at local shipyards, Langley Field, and all of the Hampton Roads Port of Embarkation camps. Despite the labor problems, Mellon-Stuart's workforce tackled the creation of Hilton with speed and determination. Area citizens stood in amazement as the heavily wooded tract was converted into a model suburban community. (Courtesy of NNPL.)

When the area for Hopkins Street was cleared, a spur track was extended from the C&O's mainline. The *Daily Press* reported on April 18, 1918, that active work clearing the building site had begun. The *Times-Herald* marveled at the prospect of how quickly "this woodland converted into an attractive development . . . with paved, well-lighted streets, granolithic sidewalks, and pleasing houses." The newspaper added that in "the clearing of the land, care is being exercised to preserve as far as is possible the natural beauty of the place, especially the park on the river bank." Trees were preserved throughout Hilton's planned streets, and in Hubbard's original plans, ways to create tree-lined, shaded avenues, roads, and streets were important features. (Both, courtesy of NNPL.)

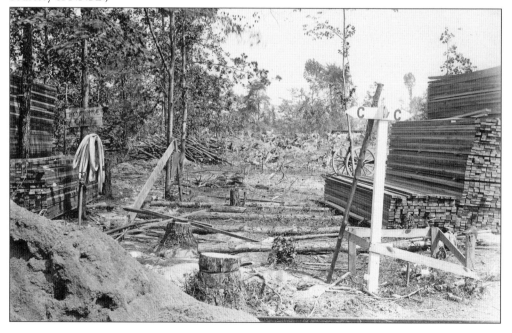

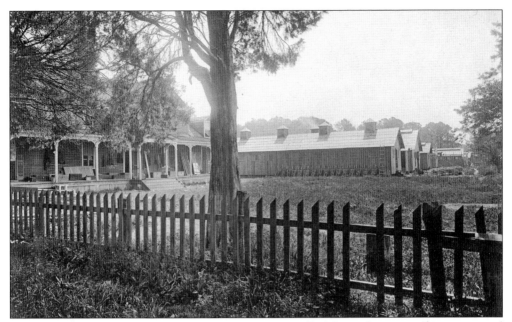

Mellon-Stuart had to build an entire work camp to house all of the workers. Barracks were erected including lavatories and showers. Segregated mess halls and a recreation facility where the men could write and read letters were constructed. Books and magazines were provided by several area welfare organizations. The men received their bunks for free, but they had to pay a dollar a day for meals. (Courtesy of NNPL.)

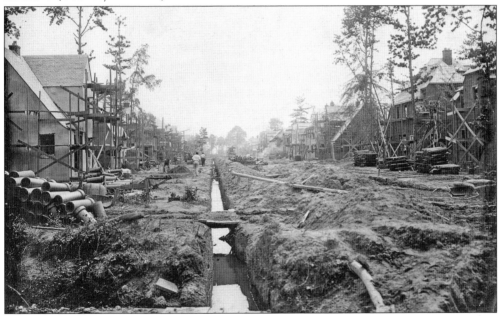

With additional equipment and supply sheds, the Hilton Village workforce camp formed almost a small town in itself. Medical services also had to be provided. "The one thing which seemed to give more comfort than anything else was the U.S. Post Office so that workmen could hear from their families at home," recalled A.C. Black, who served temporarily as postmaster for Hilton Village. (Courtesy of NNPL.)

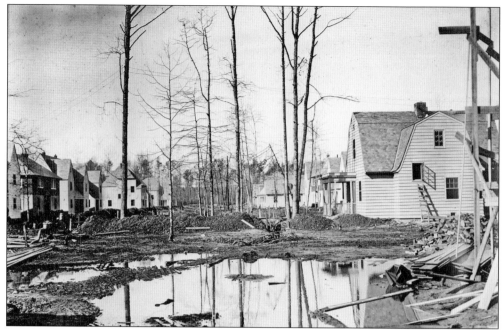

Despite the amenities of the work camp, many workers decided to live in Newport News, traveling to and from the city to work in rural Warwick County. The byway, Warwick County Road, dated back to the early days of the Virginia colony. It was an oyster-shell-and-dirt track, and wet weather turned the roadway into a deeply rutted, endlessly muddy quagmire. (Courtesy of NNPL.)

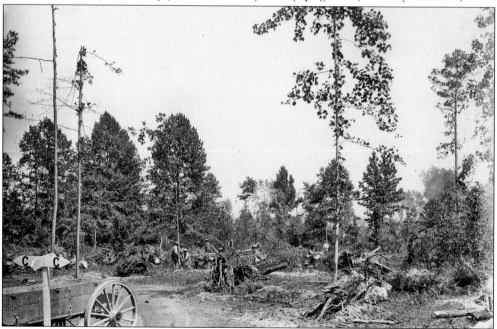

Work continued at a frantic pace, as workers needed the Hilton houses to establish good homes. Soon, streets and other aspects of this special community began to appear amongst the 90.17 acres set aside for the project. Another 5.23 acres were reserved for playfields and 6.54 acres for parkland. (Courtesy of NNPL.)

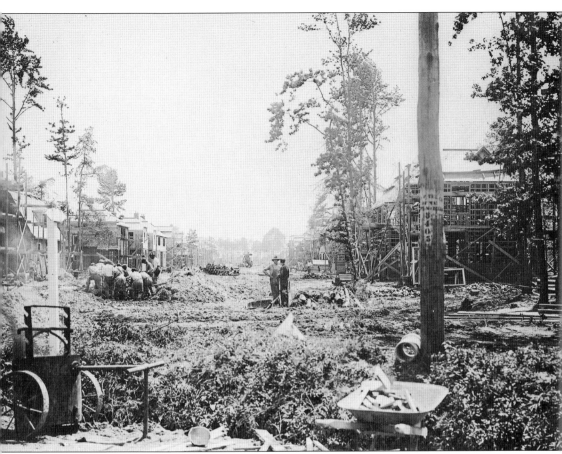

Just to prepare the land for house construction, $404,218 was expended to complete curbs and gutters, storm water drains, sewer systems, and electrical service, including streetlights, concrete sidewalks, and other amenities expected in a modern community. This expense worked out to be $632.77 per house and, when added to the house's actual construction costs, the total building expense for each house was $3,232. This figure included Mellon-Stuart's per-house profit of $100. The project's superintendent of construction was New Yorker R.A. Clements. Assistant Superintendent S.A. Seisal, also from New York, took on the project at a critical time and Hilton Village's successful construction can largely be credited to him. The civil engineers were A.G. Fancy and Frank Pearse, also from New York. The superintendent of housing was Newport News resident Thomas D. "Daddy" Higgins, who was one of the first to start on the project and remained in his position until the last house was constructed in 1919. He later worked on the dismantling of DuPont's Penniman village near Williamsburg when the war was over, and the US Navy purchased the property. Lee S. Scaly of Baltimore was the assistant superintendent of housing. (Courtesy of NNPL.)

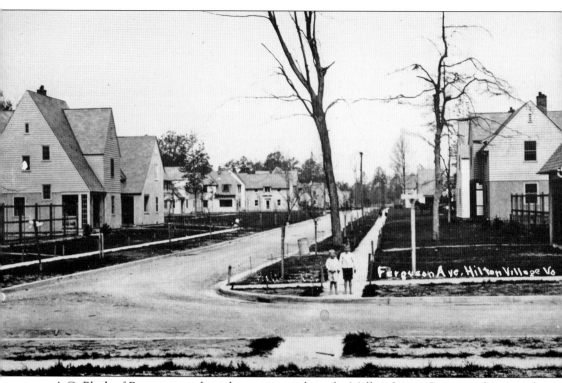

Ferguson Ave, Hilton Village Va

A.C. Black of Boston started on the project working for Mellon-Stuart Company; however, he soon became superintendent of housing for the US Shipping Board. He was later resident manager for the Shipbuilding Realty Corporation, continuing in that position until all of the houses were sold. He was considered Hilton's unofficial mayor, and when each child was born in the village, he set up a bank account in its name with a $1 deposit at the First National Bank in Newport News. He was involved in every aspect of life in the village. Producing a weekly bulletin, Black provided relevant news as well as tips on how to maintain a Hilton house and advice: "Make yourself a committee of one to keep people off the freshly paved sidewalks." He offered helpful information on various maintenance issues such as how to polish floors: equal parts linseed oil, turpentine, and vinegar. (Courtesy of John Lash.)

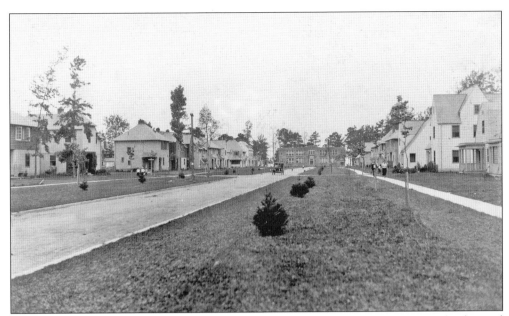

On July 7, 1918, at 2:00 p.m., a ceremony was held formally opening the new town for shipyard workers in Warwick County. A flagpole was erected at the intersection of Main Street and River Road in front of what would become Hilton Elementary School. Seating was provided for more than 1,000 attendees. The shipyard's band performed patriotic songs; also joining in was Camp Morrison's bugle corps. (Courtesy of NNPL.)

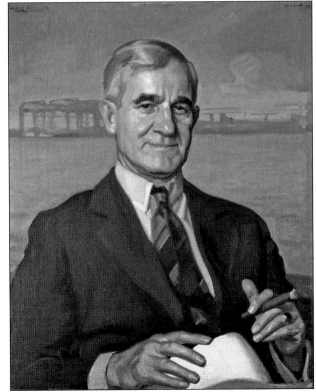

The ceremony's highlight was remarks by Newport News Shipbuilding and Dry Dock Company president Homer L. Ferguson and *Daily Press* editor and publisher Walter Scott Copeland. Ferguson congratulated the men who were building Hilton Village, noting, "They were doing noble work for their country in building homes for the men who are building the ships that were urgently needed." (Courtesy of TMMP.)

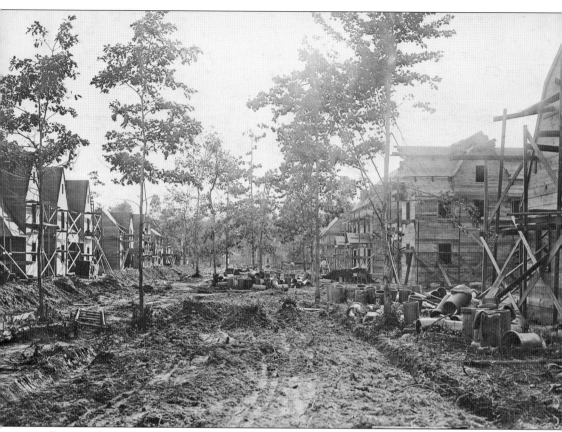

Ferguson knew that the completion of the 500 buildings called for in Hilton's design would offer homes, row houses, and apartments, enabling him to increase his workforce by 1,000 men. So, in his remarks, he rallied shipbuilders and construction workers to recognize the importance of Hilton Village. He closed with the admonition, "The yard had an immediate need for 3,000 more men and would put them to work if it had room for them . . . it is not improbable that before the war ends there will be from 15,000 to 18,000 men in the yard." Ferguson noted that the workers of Newport News Shipbuilding "were doing more work, man for man, than the shipbuilders in any other yard." He lauded the workers for rapidly building and repairing so many ships, stating their work was critical to assure that Democracy would prevail. He received a standing ovation for his work expanding the shipyard and for his extra efforts to provide housing for the yard's workforce. (Courtesy of NNPL.)

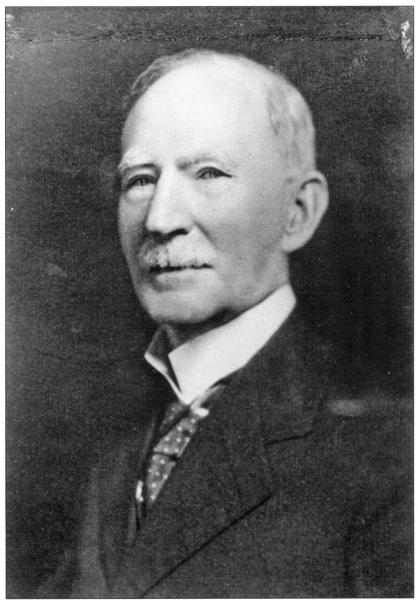

W.S. Copeland of the *Daily Press*, who spoke during the July 7 ceremony, published an editorial on July 9 praising the event. He advocated the growth of Newport News as a rising shipbuilding community and Hilton as a symbol of the city's future. He commented, "Hence the company, with the aid of the government, is building the beautiful village of Hilton for the use of the shipbuilders—500 dwellings with school houses, churches, stores. . . . And it is not improbable that the village will be doubled in size within the next year. What does this mean for Newport News? It means that the inhabitants of Hilton will purchase their homes, become permanent residents and furnish a constant supply of expert labor in the community and that means that Newport News will be a growing manufacturing city, for it has everything to make it so. We congratulate the fortunate inhabitants of Hilton and will congratulate the community. Hilton is a happy harbinger." (Courtesy of *Daily Press*.)

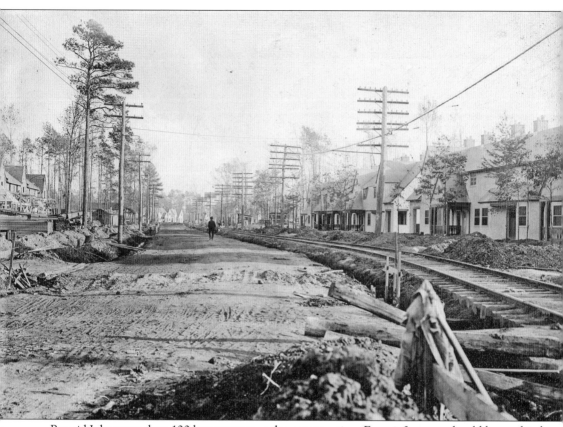

By mid-July, more than 100 houses were under construction. Francis Joannes should be credited for the ease foremen had in building. Joannes later wrote in the *Journal of the American Institute of Architects* that it was "determined to place all of the plans and elevations of each type of house on one sheet, and all of the details in connection with each type on single sheets, so that a foreman could be given one page containing all of the information he required to construct the house." The dimensions of dwellings were based on market sizes of framing lumber. The contractor was able to establish a "pre-cut" house, pre-positioned on-site, with all joists, studding, and framing cut to lengths properly piled, issued in accordance with the material schedule of each house. Most materials were ordered by the US Army, making these expenses more affordable and expeditiously delivered. On September 6, 1918, the *Daily Press* trumpeted that approximately 15 houses would be ready for occupancy, noting that the homes would have been ready sooner; however, the plumbers went on strike. After two weeks, the union disbanded and most of the men went back to work. The plumbers worked for the Noland-Clifford Company, the only Newport News firm subcontracted to build Hilton by Mellon-Stuart. (Courtesy of NNPL.)

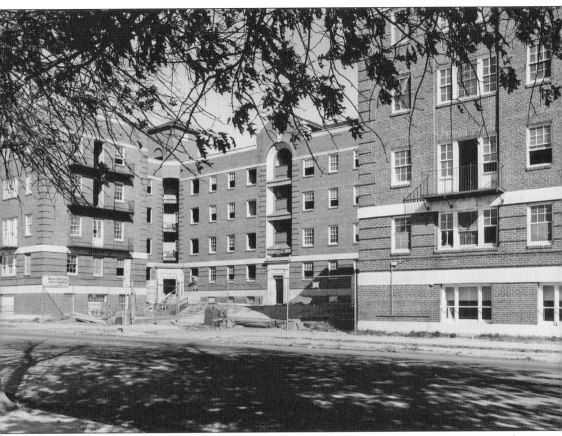

Joannes was also the architect for the Riverside Apartments (commonly called the Shipyard Apartments), built across Washington Avenue from the shipyard. These New York–style open-stair tenement-type dwellings featured two- and three-bedroom apartments and were built by James Stewart and Company of New York. The four-apartment block, built between the 4500 and 4800 blocks of Washington Avenue, was constructed simultaneously with Hilton with the same goal of making workers happy and content so that they would be more productive at work. These two major government-funded, shipyard-related housing projects proved that "government housing could be produced and administered in the United States without scandal, without extravagance, without the sky falling, or the construction going on the scrap heap," noted Henry V. Hubbard. These massive brick and Tuscan-style structures had some classically derived details around the portals and a few similar accents on the parapets. The *Daily Press* reported the apartments' appearance as "secondary to a high degree of efficiency," and their design called for the latest in amenities, including tiled bathrooms and the newest kitchen conveniences. (Courtesy of Virginia Department of Historic Resources.)

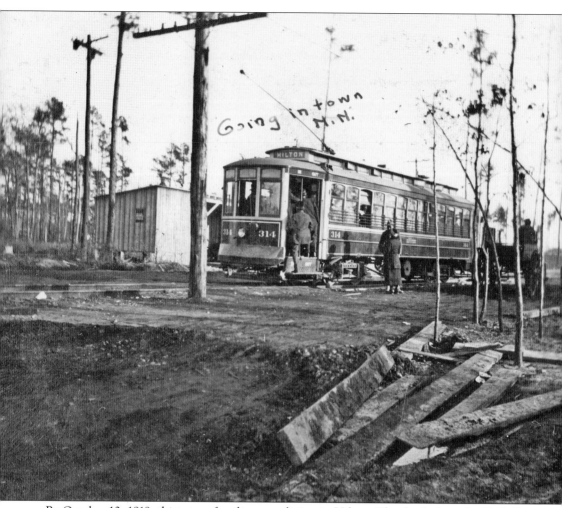

By October 10, 1918, thirty-two families were living in Hilton. The day before, the *Daily Press* announced the first streetcar run to Hilton. The car was greeted with cheers along its route from the Newport News Courthouse. It left at 2:00 p.m., crossing the city limits on a new 3.5-mile track to the gates of Camp Morrison. Regular streetcar service, connecting Harpersville, Camp Morrison, and Hilton Village, began one week later, with a total of 10 cars running the route every half hour. A.C. Black noted the first cars were "open air." He later commented that "the purpose of having them open was to prevent any close or crowded quarters during the great influenza epidemic that year." (Courtesy of NNPL.)

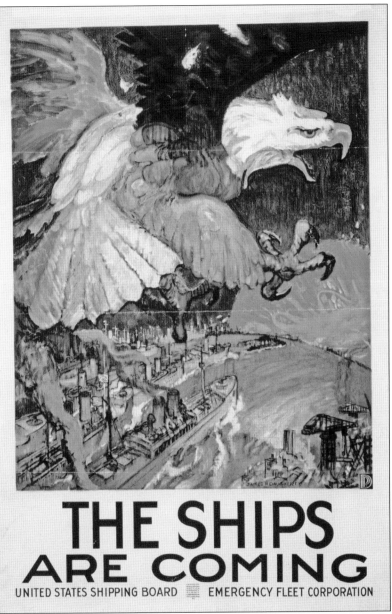

THE SHIPS
ARE COMING
UNITED STATES SHIPPING BOARD ⬛ EMERGENCY FLEET CORPORATION

The rapid German collapse on the western front caught many leaders by surprise. The arrival of American troops on the battlefields in France helped to stem the German advances, which had almost broken the Allied armies. American advances during the Meuse-Argonne Offensive forced the German army and government to collapse and sue for peace. The United States had developed Plan 1919, which would bring to Europe overwhelming numbers of American soldiers, ships, trucks, and other related supplies designed to end the war. In response, the US Housing Corporation called a halt to all yet-to-be started housing developments. Several in Newport News and Warwick County were canceled, including a dormitory near the shipyard that was to house 1,092 men; a segregated housing development, slated to be named Briarfield, for African American workers; and an extension on the north side of Hilton Village to house 465 families in what Hubbard called Hilton Village Extension. (Courtesy of LOC.)

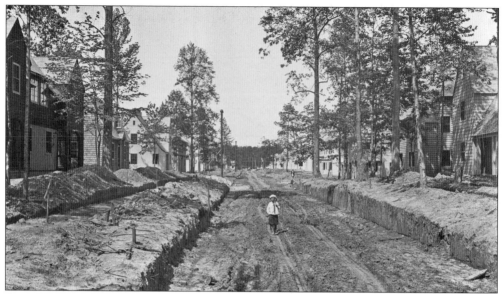

On Armistice Day, November 11, 1918, the Mellon-Stuart Company's Hilton Village contract was terminated, and the project was taken over by the Shipbuilding Realty Corporation. A.C. Black was named superintendent of housing, and J.P. Keisecker was appointed superintendent of construction. Even though more than 1,500 people were living in the village, many houses and other structures were still incomplete. (Courtesy of NNPL.)

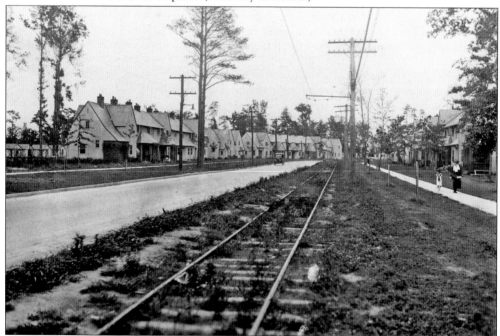

Hilton Village, other than the houses, was not completed as envisioned by the Hubbard-Joannes team. The pleasure drive along River Road looped on the western end of Hilton, providing a border to Hubbard's Hilton Extension. Since this was not built, it took travelers through the woods to Camp Morrison's main gate, where the street had a roundabout to enable the return to downtown Newport News. (Courtesy of NNPL.)

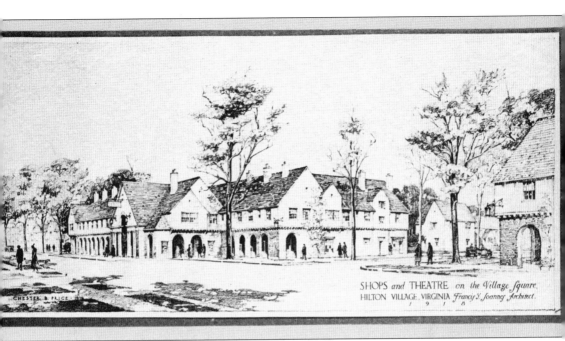

SHOPS and THEATRE on the Village Square,
HILTON VILLAGE, VIRGINIA. *Francis Y. Joannes Architect.*
1 9 1 8

CHESTER B. PRICE 1918

Several other facets of Hubbard's plan were not completed. The railroad station, apartment buildings, and many garages were not constructed, nor was Hubbard's design for the minor streets to have small central parks within the setback of the houses. Joannes had planned for the intersection of River Road and Main Street to offer community support buildings. Two churches, a school, an observation building, and a community center were to be constructed in keeping with the Garden City concepts. The Hilton Elementary School was constructed in 1919 and had no resemblance to what Hubbard and Joannes had envisioned. The simple brick structure did not match the rest of the village's English cottage style; however, the wooded park was retained. (Courtesy of Harvard Art Museums/Fogg Museum, Transfer from the Carpenter Center for the Visual Arts, Social Museum Collection. Photo: Imaging Department © President and Fellows of Harvard College.)

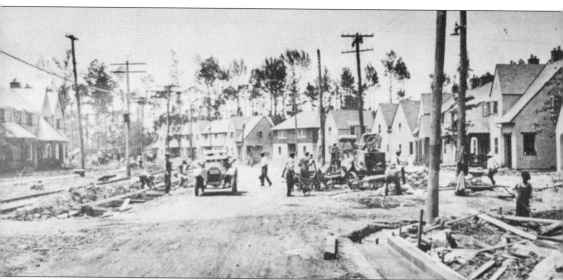

The village quickly filled with new citizens in late 1918. Rents averaged $25 to $35 per month, estimated to consume 20 percent of a shipyard worker's income. Hilton was very welcoming with a "strong sense of community spirit among their neighbors who, like themselves, were from out of state," said A.C. Black. Tenancy was by written letter and included one unusual clause that stated the "lessee could not increase his family without the consent of the lessor." John B. Locke, a housing adjustor for the US Shipping Board, noted that practically all of the Hilton homes would be lived in by shipyard workers and their families. The board's office in Newport News was filled with applications for houses on file. Locke maintained them in order of submission, except in urgent cases. (Courtesy of NNPL.)

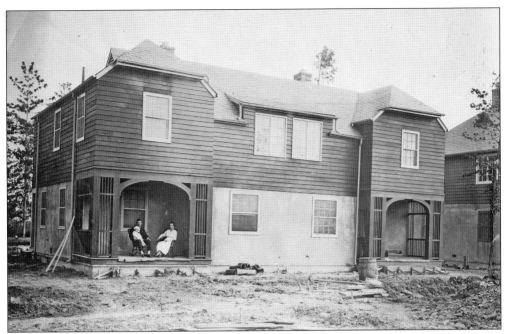

The new Hilton home layouts were well received by the tenants. The bedrooms were rather innovative, with each having a closet and built-in wardrobe dresser as well as a double bed in the wall (a Murphy bed). The living rooms in the larger Hilton homes were furnished with built-in china cabinets. (Courtesy of NNPL.)

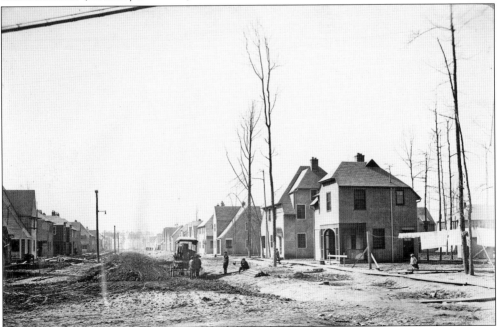

Every house had built-in kitchen cabinets and kitchen sinks, and washtubs were installed 32 inches from the floor "to prevent backache." The houses came with iceboxes for food storage, unique for their design, which included a pan to catch water as the ice melted and a drainpipe underground that directed water under the house and out into the yard. (Courtesy of NNPL.)

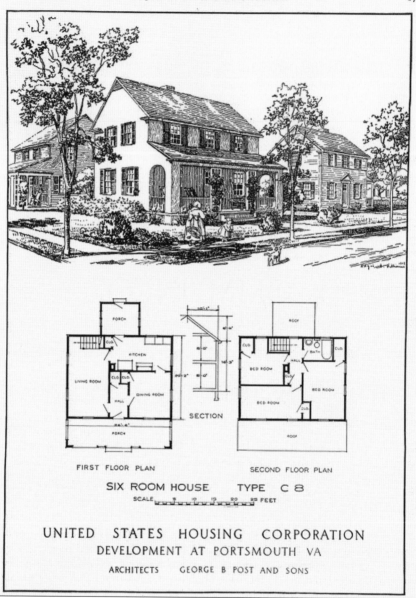

SIX ROOM HOUSE TYPE C 8

UNITED STATES HOUSING CORPORATION
DEVELOPMENT AT PORTSMOUTH VA

ARCHITECTS GEORGE B POST AND SONS

Hilton was one of several communities—including Cradock in Portsmouth, Virginia, Yorkship Village in Camden, New Jersey, and Dundalk Village in Baltimore, Maryland—built under the supervision of the US Shipping Board. This group eventually merged to form the US Housing Corporation. Led by Otto Eidletz and Joseph D. Leland III, this organization was tasked with assessing the housing needs of the entire nation. An architectural and town planning library was established in Washington, DC, with Theodora Kimball Hubbard at the helm. Hubbard, wife of Hilton's town planner, H.V. Hubbard, was on loan from Harvard to organize planning literature and related materials. The War and Navy Departments identified where housing was needed, and many plans were reaching their final stages when armistice was declared on November 11, 1918. This resulted in the eventual closing of the US Housing Corporation. (Courtesy of John V. Quarstein.)

Five

A NEW STYLE COMMUNITY

When all of the homes in Hilton Village were completed by 1920, all were occupied by tenants. Citizens watched as troops returned from the war through the Hampton Roads Port of Embarkation. One by one, the embarkation camps were closed or repurposed. Postwar retrenchment had begun. The government wanted to remove itself from the housing business, and the US Shipping Board offered Hilton Village for sale. Henry E. Huntington's Newport News Realty Company was the highest bidder, and it proceeded to offer the houses for sale, but many thought the prices were too high.

The efforts to disarm Germany and its allies prompted many to consider that the Allies themselves should disarm. Naval construction was at an all-time high because of World War I, and many feared an arms race. Consequently, the Washington Naval Treaty was signed in 1923 to limit warship construction. Fears of a possible Anglo-American naval rivalry were well founded. The United States wanted naval parity and to end the Anglo-Japanese naval treaty. The resulting disarmament treaty put limits only on capital ships; no limitation was placed on smaller vessels such as destroyers and submarines. A ratio was established between the five major naval powers: America (500,000 tons), Great Britain (500,000 tons), Japan (300,000 tons), France (175,000 tons), and Italy (175,000 tons).

Many Navy contracts were cancelled at the shipyard, and Homer Ferguson struggled to keep his workforce together. Even though the Great Depression followed in six years, somehow, Newport News Shipbuilding and Dry Dock Company survived, and as the yard's fortunes improved, so did the Hilton Village community. While many citizens of Newport News considered Hilton Village to be hidden out in the piney woods of Warwick County, it had become the county's largest town and brought families together with everlasting bonds of friendship and positive community spirit.

LITTLE
·OUR·CHIEF·

When the war ended, Hilton was rushed towards completion. Workers and their families needed the types of homes that the village offered. Quickly, this English-style village began to fill with tenants as the shipyard continued producing ships ordered in 1917. The business district witnessed the creation of new stores, and Hilton soon became a shining example of a self-contained Garden City community. The school began accepting students in 1919. Community services and churches began appearing. The fear of fires breaking out in this new community made of wood-frame houses, as well as within their own barracks and building supply piles, prompted five construction workers to organize a volunteer hose company. On November 10, 1918, the Hilton Village Fire Department (HVFD) drafted its constitution and elected H.O. Houghton as chief. (Both, courtesy of NNPL.)

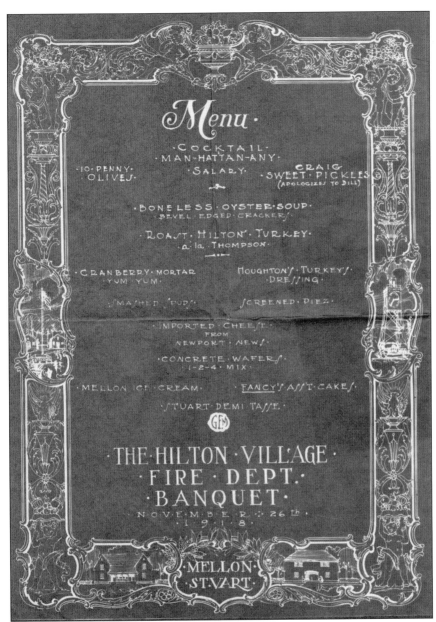

The Emergency Fleet Corporation provided the HVFD with a Ford fire truck, complete with the most modern firefighting apparatus. Soon, a second two-ton Republic truck, underwritten by the Shipyard Realty Corporation, was added to the department. The Newport News Light and Water Company (yet another Huntington-owned firm) installed 25 hydrants throughout the village. A two-story firehouse was built along with a four-story watchtower. The HVFD was Hilton's first community organization and became the hub for social activities. Volunteers provided weekly entertainment and a hugely successful Thanksgiving Day dinner in the Hilton auditorium. The HVFD solicited every resident to volunteer to help protect the lives and property of village inhabitants. New residents were prompted to watch a fire drill or to get acquainted with club members. The department's motto was "In Hilton Village, of Hilton Village and for Hilton Village." (Courtesy of John Lash.)

Since most of the initial volunteers were construction workers, the HVFD issued an emotional plea to the new residents of the village, declaring, "It is to your own individual benefit to see that your home is protected in case of fire. . . . Show your loyalty to your adopted home town and your fellow neighbors by becoming a member of the Fire Department." The appeal worked, as each new resident did join. The HVFD obtained Homer Ferguson's approval to secure the use of the original Hilton house as a clubhouse. The house, located on the riverbank down a hard dirt road from the firehouse, was to be used to promote social life among the members. Improvements were made possible by money secured from memberships, paid entertainments, and profits from the soft drink stand. The fire department was able to raise $5,000 to build the Hilton Pier and Boat House, which became a very popular venue during the summer. (Courtesy of *Daily Press*.)

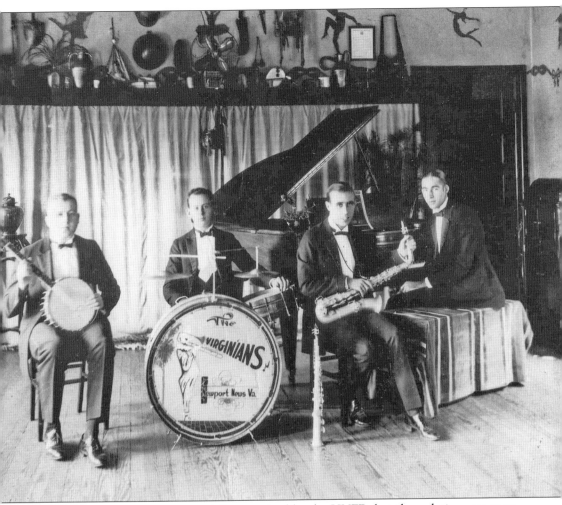

Hilton auditorium events were initially organized by the HVFD, but these duties were soon assumed by a new group known as the Hilton Village Civic League. Eventually, the civic league took over the operation of the fire department and, in the words of A.C. Black, "was a grand organization, always standing up for the rights of the citizens of Hilton Village." The auditorium was a popular community asset and was available for dances, club meetings, church activities, and school gatherings. Christmas bazaars, special dinners, and even Morrison High School graduation exercises were also staged there. Often, Palen Avenue resident and shipyard worker Rossa A. Callis Jr., known as "the Piano Man," would accompany silent films played in the auditorium. In the early evenings, neighbors could hear Callis practicing his melodies. He also headed the popular band the Virginians, who played for dances in the auditorium. (Courtesy of Virginia Callis.)

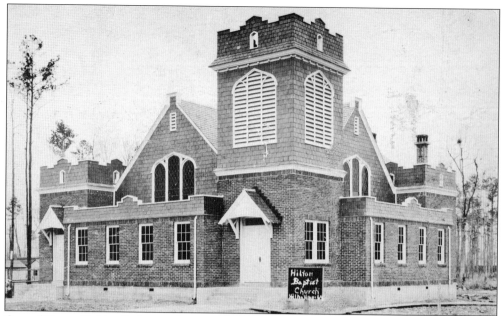

One of Henry Hubbard's design themes was the presence of two churches at each end of Main Street. This consisted of empty lots that were to be sold to denominations for a dollar. In 1919, shipyard president Homer L. Ferguson gave four denominations land as well as a Hilton house next door for use as a parsonage. The Baptists were the first to organize. They began construction on August 16, 1920, and the Baptist church opened its doors on January 9, 1921. (Courtesy of John Lash.)

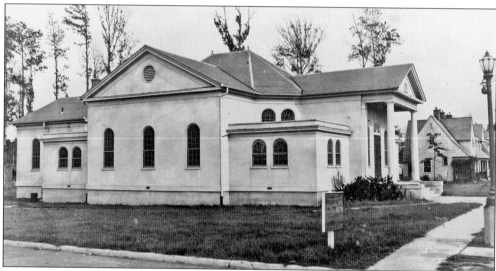

The Episcopalians were next. They began building St. Andrew's on April 13, 1920. This sanctuary would be replaced in 1955 and also accommodated St. Andrew's Episcopal Day School. The Presbyterians had joined forces with the Methodists to hold services together and to construct a base upon which to build their own churches. The Hilton Presbyterian Church opened on October 9, 1921, whereas the Methodists began constructing their church on June 20, 1920. The Baptist and Methodist churches were at Warwick Road and Main Street, while the Presbyterian house of worship was at River Road and Main Street. (Courtesy of NNPL.)

One of the major reasons for the limited house sales was the Washington Naval Treaty of 1922, which endeavored to discuss how to avoid the developing arms race between the victorious Allies. Consequently, a 10-year "holiday" on capital ship construction was established. Newport News Shipbuilding was informed by telegram that the US Navy was cancelling $70 million worth of contracts. Construction of the battleship *Iowa* and the battle cruiser *Constellation*, already in progress, was ordered scrapped. (Courtesy of NNS.)

When the houses were offered for sale, they did not sell, despite the advantageous terms of 10 percent of the purchase price in cash with a 6 percent–interest mortgage for 10 years with equal monthly payments of 1 percent of purchase price. In 1926, the Newport News Realty Company installed natural gas in Hilton Village and then created six model houses on Main Street. Each house was furnished and the yard landscaped so that prospective buyers could see what could be done with a Hilton house. The newly formed Woman's Club of Hilton Village obtained one of these houses. (Courtesy of Michael Poplawski.)

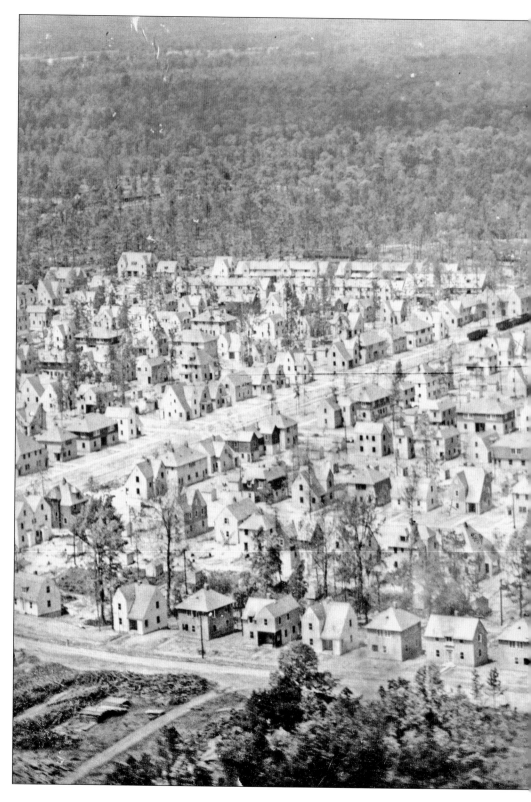

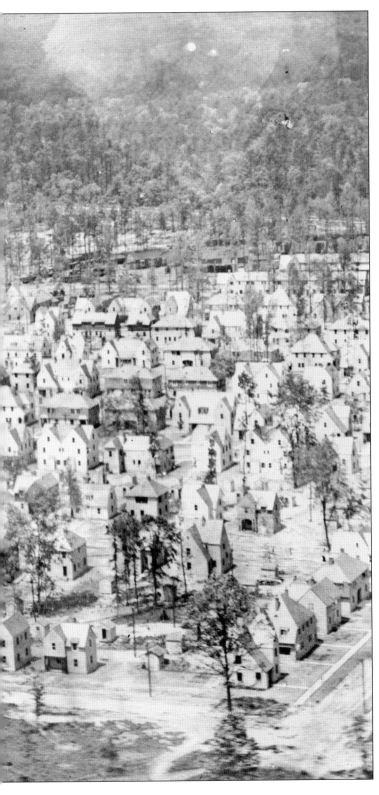

In 1921, Hilton Village was purchased by Henry E. "Eddie" Huntington. He was Collis P. Huntington's nephew and had married Collis's widow, Arabella Yarrington "Belle" Huntington, after his uncle's death. In an effort to disguise his intentions and to separate any fiscal connection with the shipyard, Huntington organized the Newport News Realty Company. Simultaneous with Huntington's acquisition of Hilton Village from the US Shipping Board, the desire "for home ownership was stirring among Hilton residents," said A.C. Black. The houses were appraised and offered for sale. A six-room house was priced at $2,800; however, this price appeared too high, as an entire year passed before the first house was sold. Huntington's goal was to create a community and avoid any real estate speculation. Accordingly, an individual could only purchase one house. (Courtesy of NNPL.)

Homer Ferguson did everything he could to keep his workforce together, including underbidding on the conversion of the *Leviathan*. Once the largest passenger liner in the world, known as the *Vaterland*, it was used as a troop ship during the war and was brought back into service as a passenger liner. The yard lost $1.4 million on the job. Eddie Huntington, realizing that Ferguson had acted in the best interest of the city, told the shipyard president, "My wife owns most of the stock in the shipyard, and she has not been feeling well recently, so maybe we should say no more about it." The shipyard accepted whatever work it could, such as building wind tunnels for NACA, locomotives, and pleasure yachts. Ferguson recognized the need for diversification, but he lamented that "I suppose it is fortunate that we can do something else . . . but no one born and bred to the business of building ships can get enthusiastic about it. Who, who could love a boxcar." (Courtesy of NNS.)

H.E. Huntington's Newport News Realty Company moved to revitalize Hilton Village with the construction of the Colony Inn, located at the intersection of Warwick Road and Main Street. It replaced a 1918 officers' club serving Camp Hill and Camp Morrison and incorporated 10 existing Hilton houses. J. Philip Keisecker of the shipyard suggested to Huntington that an inn be created in Hilton. Keisecker believed that an inn would offer a quiet, appealing stopping place for the visitor to the Peninsula and the community. Huntington agreed and underwrote the Colony Inn's construction, according to Keisecker, "to establish good public relations between the shipyard and the community." He also wanted "to impress people that the shipyard was willing to spend money locally." The Colony Inn was built in two sections. The south portion consisted of three row houses (90, 92, and 94 Main Street) and two single homes (96 and 98 Main Street) linked together. (Courtesy of NNPL.)

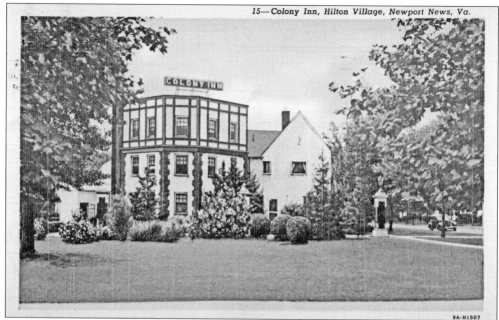

Original plans called for an eight-story tower with a roof garden. The tower was not built as planned, stopping at the third story. Also abandoned were the roof garden and proposed swimming pool. The south section featured 17 guest rooms. Across Main Street to the north were additional accommodations of 18 rooms using the homes at 91, 93, 95, 97, and 99 Main Street. The acquisition and construction cost for the inn was $80,000. (Courtesy of John Lash.)

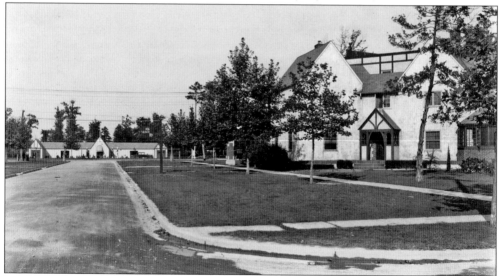

Promoted as "An English Inn on the American Plan," the Colony Inn featured Tudor Revival architecture enhanced by its charming interior decor. An inn brochure states, "The main building itself is furnished throughout with the lobbies, large rooms, and office on each side of the entrance." Most of the public rooms' ornate furnishings came from the German passenger liner SS *Vaterland*. This large liner was interned in 1914 and converted into the troop ship USS *Leviathan* in 1917. When the war ended, Newport News Shipbuilding and Dry Dock Company converted *Leviathan* back into a passenger liner. (Courtesy of NNPL.)

The inn had numerous English designs, with "handmade benches and fireguards in front of all chimneys and just off the lobby is an old English tavern bar," the *Daily Press* reported. The dining room was divided into three rooms. One of these spaces was a sun parlor with high, broad windows. On one end of the main dining section was a large, decorative map of the Virginia Peninsula by Thomas C. Skinner. Noted as one of the "South's Fine Hotels," the Colony Inn had a sterling reputation for its fine southern cuisine. The delights prepared by master chef Elijah Meekins and dietician Mildred Lankin ensured the inn maintained its listing in Duncan Hines's *Adventures in Good Eating.* Meals were advertised as 45¢ for breakfast, 75¢ for lunch, and $1 for dinner. Dinner was a formal affair, so gentlemen had to wear coat and tie, and ladies, dresses suitable for dinner. Garland Mosely recalled going to the inn for dinner with his parents and having his first taste of caviar there. John "Bud" Lankes remembered that the "dining room was a nice place to go; the food was excellent." (Courtesy of NNPL.)

The Colony Inn was a posh hotel, and several Hilton residents declared that they had seen many Rolls-Royces pull up to the entrance. June Waters, then a fifth grader at Hilton Elementary, walked every afternoon from school to the inn for her piano lessons. She was admitted by a butler in a white coat who escorted her to the baby grand piano in the formal dining room. As she strode over the slate floors, she passed by the impeccably set tables with pressed white cloths. She declared she "felt like a princess." Many noted Americans stayed at the inn, such as Pres. Herbert and Lou Henry Hoover, as well as three first ladies—Edith Wilson, Grace Coolidge, and Eleanor Roosevelt—in town to attend vessel launchings or other special events on the Peninsula. Poet Robert Frost was another notable guest at the inn. One advertisement stated, "Each of the Inn's rooms is an outside room with plenty of windows and well ventilated. Many of the rooms have connecting baths. Each room has a telephone and those rooms which do not have baths have running water and are convenient to baths that will be used by only one or two rooms." (Courtesy of John Lash.)

The rate at the inn for a single room with a bath was $3.50 a night. In each building, the *Daily Press* reported, "are attractive suites, with sitting room, bedroom and bath." The guest rooms were grouped in twos. The wall decorations carried out the English effect. The north section also featured "several club rooms suitable for afternoon teas, card parties, and the like." (Courtesy of NNPL.)

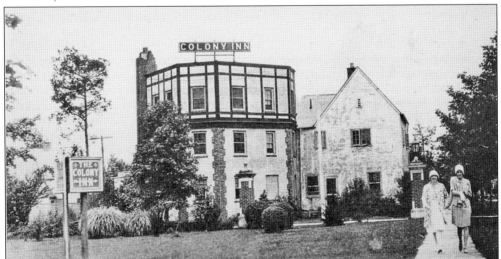

The best accommodation was the Huntington Suite, replete with a king-size bed custom made for Archer Huntington, who was six feet five inches tall. The Colony Inn was an amazing place and fit into Hilton Village perfectly with its old English appearance, inside and out, which enhanced the feeling that one was not in Warwick County, Virginia, but somewhere far away in the British Isles. (Courtesy of John Lash.)

During the 1931 Yorktown Sesquicentennial, the Colony Inn advertised that is was an easy drive on the concrete road from Jamestown, Williamsburg, and Yorktown. Other notable guests at the inn included Philadelphia industrialist Archibald McCrea and his wife, Mollie. They purchased Carter's Grove Plantation outside of Williamsburg in 1928. The mansion required extensive restoration. So for several years (these were the days before the Colonial Williamsburg restoration

really got under way; there was no Williamsburg Inn), the McCreas chose the Colony Inn as home while their house was being renovated. First Lady Eleanor Roosevelt was a guest at the inn when she visited Hampton in support of the creation of the African American neighborhood Aberdeen Gardens. It is also believed that award-winning poet Robert Frost stayed at the inn when he visited noted woodcut artist J.J. Lankes's studio in Hilton Village. (Courtesy of John Lash.)

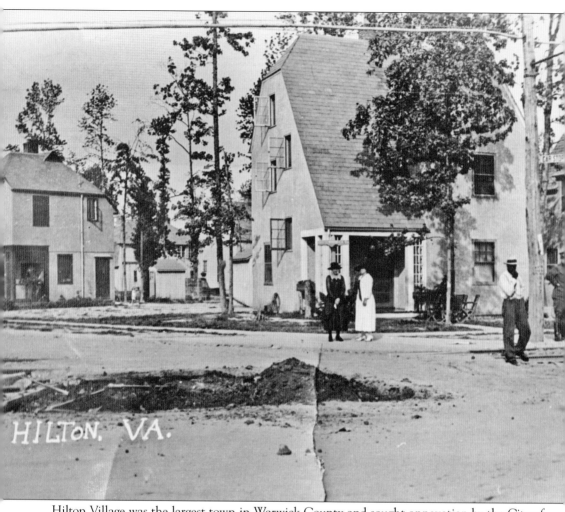

HILTON. VA.

Hilton Village was the largest town in Warwick County and sought annexation by the City of Newport News, hoping to share in the improved streets, schools, and lighting. However, the Newport News City Council rejected the proposal, as many felt that Hilton was located so far out in the woods and according to then Newport News vice mayor Harry Reyner, there were "chickens running at large in the village." There may have been some truth to that statement. Royden Goodson remembered living on Post Street where his father kept a dozen or so Rhode Island Red chickens in the backyard, and occasionally a few might escape from their pen, "causing a ruckus" along the street. Nevertheless, in 1928, Hilton Village was 10 years old and had survived the lean times of the "Naval Holiday." The *Daily Press* declared that the village was "a beauty spot architecturally . . . and a thriving community." Hilton's population then stood at 1,600. Out in the wilds of Warwick County, life did appear idyllic as one strolled the streets or walked along the pier. Hilton Village was a beautiful enclave unto itself, and its citizens understood that life along the James River was indeed unique. (Courtesy of NNPL.)

Six

The City Comes to Hilton

Somehow, Hilton Village survived the Naval Holiday years, but when the Great Depression struck, Hiltonites feared that the shipyard might not be able to weather this second storm. Homer Ferguson was able to find other work wherever he could until the US Navy decided that more ships were needed to protect America's global interests. The contract to build the USS *Ranger* was the beginning of Newport News Shipbuilding's revitalization. More aircraft carriers, freighters, and other warships quickly followed as the rise of fascist dictators began to threaten world peace.

The shipyard's expansion (the payroll rose from 9,765 in 1939 to more than 31,000 by 1943) had a huge impact on Hilton Village. Henry Hubbard's Hilton Extension became a reality when Brandon Heights was constructed. Other neighborhoods bordering Hilton, like Rivermont, were built as the wartime boom witnessed more and more families moving into Newport News to staff and build Hampton Roads Port of Embarkation camps, erect new housing, and construct ships.

In the midst of war and the Depression, Hilton was home to some of America's greatest artists and writers. William Styron, J.J. Lankes, and T.C. Skinner all added to the village's fabric in a fanciful fashion, setting an amazing standard for others to follow.

Hilton came into its own during the period from 1918 to 1945. The village turned 25 years old in 1943; few could have imagined that a wartime housing community would become a major keystone for Warwick County and the city of Newport News.

On November 17, 1928, the James River Bridge, connecting the Peninsula with the Southside, opened to the public. An estimated 80,000 people attended the gala affair with floats, bands, a two-mile-long military parade, and an aerial review overhead from Langley Field. Pres. Calvin Coolidge pushed a button that lowered the massive lift span, poised 147 feet above the high-water mark of the James River. (Courtesy of TMMP.)

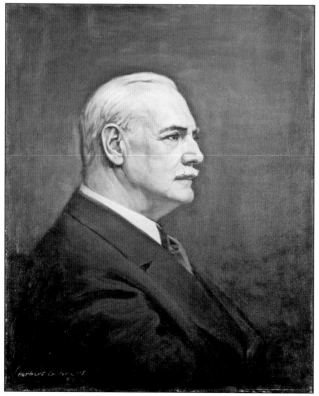

As the Great Depression struck the Peninsula, the shipyard somehow managed to weather the financial crisis. It was able to meet its payroll on time and in cash due to the vast resources of Archer Milton Huntington. Huntington was then owner of Newport News Shipbuilding and Dry Dock Company, after the deaths of his mother Arabella Huntington in 1924 and his cousin Henry E. Huntington in 1927. (Courtesy of TMMP.)

Homer Ferguson was determined to keep the yard and his workforce intact. The yard did receive several ship contracts from the US Navy, including the cruisers *Augusta* and *Houston* in 1927 and in 1930, the first Navy aircraft carrier constructed from the keel up, the USS *Ranger*. The shipyard continued to look for additional work, including Millikin traffic lights for New York City. Perhaps the most spectacular non-shipbuilding contract was the fabrication of what was then the largest turbine in the world for the Dnieprostroi Dam project on the Dnieper River in the USSR. Nine turbines were built; each could produce 84,000 horsepower utilizing a solid steel shaft 433 inches in diameter, weighing 50 tons. (Both, courtesy of TMMP.)

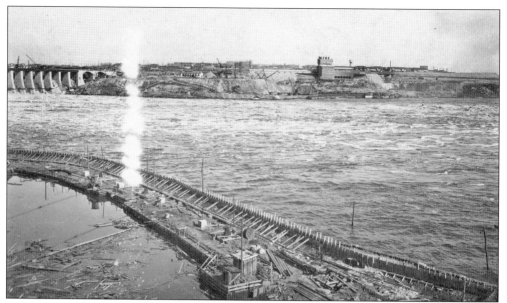

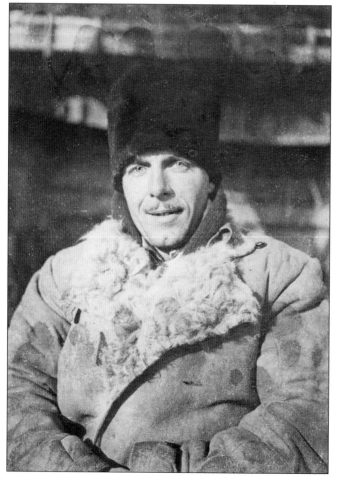

When Claude O. Jones (at left) left Newport News in 1929 to work on the Dnieprostroi Dam project, he shared with his family that most of Europe was falling into what would become known as the Great Depression. He telegraphed his wife, Frances Marie, telling her to take their savings out of the bank and to buy a house in Hilton Village. Mrs. Jones did as he asked and purchased a duplex on Piez Avenue. The purchase was finalized just two weeks before Black Friday, October 29, 1929, when the Depression reached America. The shipyard sent a few employees to the USSR to supervise the work installing the turbines. When the dam opened in 1932, Jones and Fred Malarkey received cash awards. The Russians decorated George Binder and Fred W. Winter with the Order of the Red Banner. (Both, courtesy of Claude O. Jones III.)

By 1940, the entire Peninsula was preparing for war as conflict raged throughout the world. In downtown Newport News, future author William Styron remembered that "life was dominated by the biggest shipyard in America . . . and by the outlines of such Naval behemoths as *Ranger* and *Yorktown* and *Enterprise,* each of which as a boy, I witnessed slithering majestically down ways loaded with tons of sheep tallow into the muddy James, which parted at the prodigious impact like the Red Sea, making way for Moses. It was an incredibly busy, deafening world I grew up in—all technology and energy revving up for the greatest clash of arms in history." The rapid increase of US Navy contracts tripled the shipyard's work, and numerous other companies expanded as well. The Newport News–based Virginia Engineering Company received more than $150 million in government contracts with a workforce of 19,028 men and women. Once again, more wartime housing was needed. Many new neighborhoods were constructed, like Briarfield Manor, but none of them matched the Garden City design approach found in Hilton Village. (Courtesy of TMMP.)

LOOSE LIPS MIGHT Sink Ships

THIS POSTER IS PUBLISHED BY THE HOUSE OF SEAGRAM AS PART OF ITS CONTRIBUTION TO THE NATIONAL VICTORY EFFORT

SEAGRAM-DISTILLERS CORP. N.Y.C.

Shortly after the Japanese attack on Pearl Harbor, the coasts of the United States braced for attack. German submarines operated off the Chesapeake Bay. The volunteer Virginia Aircraft Warning Service was established, and a lookout post was created atop Hilton Elementary School. Village residents dutifully performed this service, warding off fatigue and coping with the elements. "You can imagine what it was like standing up there on a cold winter night . . . shivering for three hours . . . you just could not keep enough clothes on," John Millar remembered. He also said, "In the summertime, it was just as bad with the heat. As soon as the sun set the mosquitoes rose in swarms and would carry you off alive." Despite the constant watching, only American plane silhouettes were ever seen. Others served as air raid wardens. Suzanne Brooks recalled that when the practice air raid warning signal went off, her father "would put on his armband and check that all of the neighbors had their lights blacked out." (Courtesy of Virginia War Museum.)

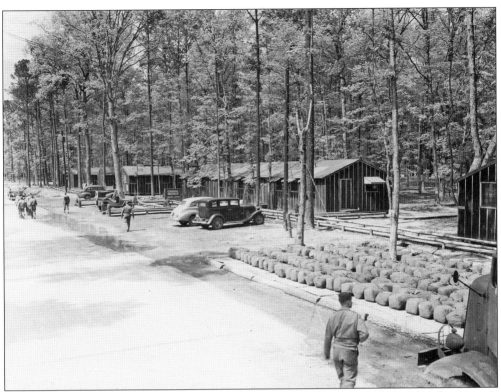

Newport News was once again named the Hampton Roads Port of Embarkation headquarters. It was commanded by Brig. Gen. John Reed Kilpatrick and included the former World War I port installations of Camp Hill and Camp Morrison and a huge new embarkation camp covering 1,700 acres known as Camp Patrick Henry. This camp had the capacity to support 35,000 soldiers at one time, and it employed 7,000 civilian workers. (Courtesy of TMMP.)

As the war began to turn in the Allies' favor, many German and Italian prisoners of war settled into camps at Fort Eustis and less than a mile from Hilton at Camp Hill. In September 1943, when Italy switched sides in the war, these POWs were employed loading and unloading vessels at the Newport News terminals, at farms in Warwick County, and as waiters at the Colony Inn. (Courtesy of TMMP.)

The Colony Inn

In 1942, the Colony Inn was leased by the Army for officers' quarters as well as to serve as an officers' club. First Lt. Charles "Norm" Stevens returned after 34 bomber missions over Europe to Langley Field. Many nights, Langley officers would drive over to Hilton Village, which Stevens described as "a collection of steep-roofed, English-styled homes." Young Lieutenant Stevens recalled approaching the inn across a lawn of grand old shade trees. He knew the Colony Inn

on Village, Va.

was "the only action in town." During his first visit, Stevens was "surprised that all four waiters are Italian prisoners of war. They speak very little English." He did communicate fairly well with one Italian who said that "Rome is the best place to go in Italy and that Naples is the worst. . . . Naples is even worse than Newport News." (Courtesy of John Lash.)

Stevens came from a teetotaling family; however, at the Colony Inn, "I was introduced to Coke Highs—Coca Cola mixed with a shot of bourbon." According to Stevens, "The drink tastes like a refreshing Coca Cola, but the effects are strangely different. As I sip them I begin to feel a sense of well-being, melting away inhibitions, a release." He had only just returned from the European combat theater a few months before and had never before "dealt with the terror of bombing missions. . . . All those experiences must be working on me, accumulating inside of me, like water between a dam. Maybe that's why a Coke High gives me such a sense of relief. . . . Next Sunday night will again find me at the Colony Inn." Fortunately, Stevens never returned to combat, as the war ended in September 1945. Hilton Village was changed by the war. It was no longer an isolated, separate community surrounded by forests and farms, as suburbia had grown up all around the village and harbored great changes during the postwar era. (Courtesy of Charles N. Stevens.)

Amidst the woes of the Great Depression and the fears brought forth by World War II, Hilton Village was home to several significant artists and writers. The independent, quaint English-style village overlooking the James River must have fostered a special sense of genius that left the entire nation with a tremendous legacy. *The Crabber*, pictured here, was produced by Julius John "J.J." Lankes and captured his Hilton neighbor Langhorne Ficken dipping for crabs on the James River next to the old, rickety pier. Lankes's artistic skills prompted the noted author Sherwood Anderson to call him "the Virginia wood cut man," noting that Lankes had "that rare, charming faculty, so seldom found nowadays, of getting delight out of everyday life." Lankes's wife, Edie Maria Bartlett, had been convinced by her brother, MIT graduate Lawrence Bartlett, who worked at the shipyard and lived on Post Street, to move to Hilton Village. The Lankes family first moved to 218 Palen Avenue and purchased a residence at 306 River Road soon thereafter. (Courtesy of *Daily Press*.)

Liberator

March, 1920 25 Cents

The First Interview with Bela Kun in Austria
Dissolving The Duma at Albany--by Robert Minor
Communism on Trial--by Arturo Giovannitti and William Gropper
Robert Lansing Explains Bolshevism--by Max Eastman

J.J. Lankes was born in Buffalo, New York, in 1884. After graduation from college, he studied art at the Art Students League of Buffalo and then School of the Museum of Fine Arts, Boston. Unsuccessful as a painter, Lankes turned to woodcut art in 1917; his skills were immediately recognized as outstanding. His major commission was a woodcut for the front cover of Max Eastman's Communist Party–connected magazine, *Liberator*. Lankes found many kindred spirits there and was listed on the masthead as a contributing editor. Although he modified his radical leftist views as he grew older, Lankes retained his tremendous disdain of the bourgeoisie and his admiration for the working class. He summed up his political beliefs in a letter dated January 8, 1929, to Sherwood Anderson: "I was an ardent Socialist at one time, and then a Communist—I was all for the workers." His woodcuts often fill the viewer with a sense of tragedy due to his depictions of a deep sympathy for the unattractive conditions of life. (Courtesy of Marxists Internet Archive, www.marxists.org/history/usa/culture/pubs/liberator/#1920.)

The great American poet Robert Frost began working with Lankes in 1923; they quickly forged an artistic friendship. Frost noted that he and Lankes shared "a coincidence of taste." When Frost's poem "The Star Splitter" was featured in the popular magazine *Century*, he chose Lankes to produce a woodcut series to decorate the work. This collaboration worked because they were both masters of form and simplicity, sharing a realistic style and a yearning for perfection in their respective fields of art. Lankes continued to illustrate Robert Frost's poetry over the following decade, including the Pulitzer Prize–winning volume *New Hampshire: A Poem with Notes and Grace Notes*, published in 1923. Lankes worked with other important artists, including Beatrix Potter and Sherwood Anderson. His friendship with author Roark Bradford resulted in Lankes producing 25 woodcuts for the award-winning 1931 novel *John Henry*. The woodcarver's name appears on the cover, and his illustrations within vividly present the secrets of John Henry's strength and soul. Lankes worked on numerous other important projects, including a folio project with his River Road neighbor, Eugene Eager Wood, entitled *Virginia Woodcuts*. (Courtesy of Library of Virginia.)

Lankes was persuaded by Robert Frost to accept a position as a visiting professor of art at Wells College in New York. His lectureship was underwritten by the Carnegie Fund for Practical Arts. Lankes's family remained in Hilton while he was away teaching. His contract was terminated in 1938. Nevertheless, Lankes continued his illustrious career as an artist. He made woodcuts for a new edition of Thomas Gray's "Elegy Written in a Country Churchyard," which was introduced by Pulitzer Prize–winning poet Robert P.T. Coffin. He also produced a series of woodcut images for the Colonial Williamsburg Foundation of unrestored structures on Duke of Gloucester Street. Lankes often walked out in the woods surrounding his Hilton Village home; he chanced upon the long-abandoned Colonial-era Massey House, sited on a bluff. This was a very popular subject for Lankes's work. The building's high-pitched roof, prominent exterior chimney, and sunbaked clapboards enabled him to create remembrances of old Virginia. Sherwood Anderson writes about Lankes in his 1934 book, *No Swank*: "I like things in my dining-room that arouse, that awaken thoughts in me. So, I have these Lankes woodcuts.... I honor him for his realism, the man has feeling. He has that odd quality, so infinitely valuable. The feeling for things, for the reflected things in life." The close friend of poets, authors, and artists, and the author of the first respected and comprehensive book on woodcutting published in North America, J.J. Lankes' produced a vast body of work that expresses the variety and quality of Hilton Village's unique workingman's experience. (*Frost's House*, woodcut, courtesy of the Estate of J.J. Lankes.)

In 1943, Lankes accepted a position as head of technical illustrating at the National Advisory Committee for Aeronautics (NACA) at Langley Field. While he was unhappy there teaching technical drawing, he was able to create his favorite subject, holiday cards. Even though NACA proclaimed that Lankes was "one of the most outstanding woodcut artists of the country," he shared "some strong language with Civil Service sewer sleuths" and was dismissed. He felt that he was fired for political reasons, and he met with a lawyer to try to get his job back. He was told that he was fired because he was "a Communist." Lankes was under scrutiny by the House Committee on Un-American Activities, which was especially concerned about "Red" artists. Lankes's work with the *Liberator* and his association with other leftist organizations linked him with the people and groups that were being investigated. He moved to Durham, North Carolina, and died there in 1960. (Courtesy of NASA.)

A Hilton Village resident who is often overlooked is Thomas C. "T.C." Skinner. Born in Kentucky, he grew up in Waynesville, North Carolina, where he began to show his artistic abilities as a youth. He studied at the Art Students League of New York. He then went to study in Europe, where he met his wife, Theresa Tribolati. The Skinners moved to Newport News in 1928, when they created art to decorate the Colony Inn. The couple decided to make the inn their home.

Skinner just so happened to be the brother of Elsie Skinner, wife of shipyard president Homer Ferguson. Accordingly, Skinner was named staff artist for the shipyard and was provided studio space there. When Archer Milton Huntington established The Mariners' Museum, Skinner was given the additional duty of serving as the Museum's official artist. (Courtesy of TMMP.)

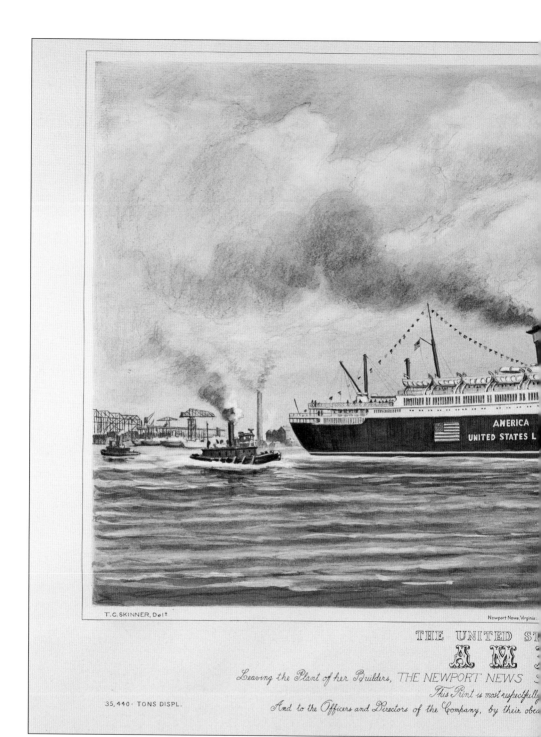

T.C. SKINNER, Del.ᵗ

Newport News, Virginia:

THE UNITED ST

A M

Leaving the Plant of her Builders, THE NEWPORT NEWS

This Print is most respectfully

35,440 · TONS DISPL.

And to the Officers and Directors of the Company, by their obe

While painting at the shipyard, T.C. Skinner produced covers for the yard's *Apprentice School Yearbook* and the *Shipyard Bulletin*. Homer Ferguson thought that his work was "wonderful . . . fashioned with the eye of a draftsman." Some of his most famous works portray the heavy cruiser USS *Newport News*, the launch of the tanker *ESSO Gloucester*, and, in a 1952 painting, the liner SS *United States*. His SS *America* painting of the fast passenger liner leaving the shipyard in her

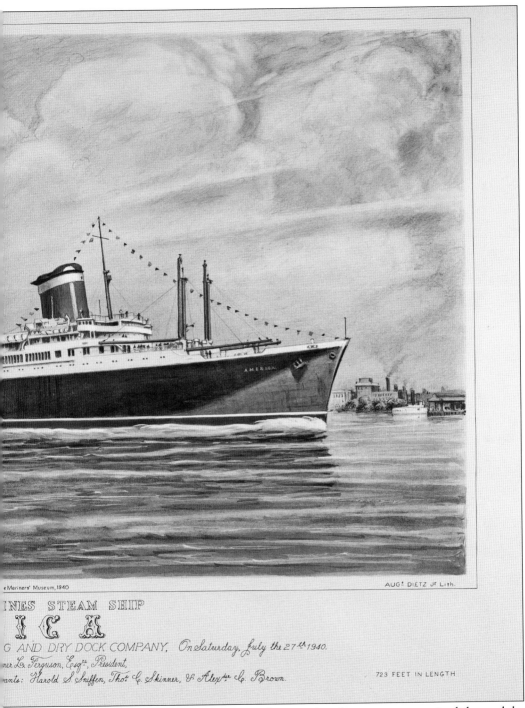

e Mariners' Museum, 1940

AUG⁺ DIETZ J⁺ Lith.

INES STEAM SHIP
I C A
G AND DRY DOCK COMPANY, *On Saturday, July the 27ᵗʰ 1940.*
ner L. Ferguson, Esqʳˢ, President,
ants: Harold S. Sniffen, Thoˢ C. Skinner, & Alexⁱʳ Cₒ. Brown.

723 FEET IN LENGTH

wake and heading seaward to her destiny was later produced as a commemorative lithograph by The Mariners' Museum. His most important work for The Mariners' Museum was a series of 10 huge murals that were bold, colorful, and almost noisily true-to-life glimpses of the bygone era of heavy industrial shipbuilding. Skinner passed away in 1955. (Courtesy of TMMP.)

Another noted 1930s resident of Hilton Village was William C. "Bill" Styron Jr., one of the 20th century's leading American novelists and essayists. He grew up at 56 Hopkins Street and attended Hilton Elementary School. Styron noted that Hilton and the surrounding woods were idyllic, "almost a sanctuary, the perfect place to be a kid. The antithesis of the place where bad things happened. If you locked your doors, it would be an insult to your neighbors." Styron left Hilton to attend Christ Church School and never returned until the 1990s. In the meantime, he went on to receive numerous awards during his career, including the American Academy's Rome Prize for his first novel, *Lie Down in Darkness*. Published in 1931 and set in the mythical Tidewater Virginia town of Port Warwick, the work was based on the dysfunctional, quasi-gentrified world of his hometown, Newport News. He was awarded the Pulitzer Prize for Fiction for his controversial novel *The Confessions of Nat Turner*, based upon Nat Turner's rebellion, which took place in 1831 in nearby Southampton County. (Courtesy of NNPL.)

Seven

Preserving the Village

After World War II, Hilton seemed to have picked up just as it was before the conflict. Yet nothing could remain the same, as World War I had brought thousands of new citizens to Newport News and Warwick County. As the post–World War era turned into the Cold War, the shipyard still hummed, building more warships. The Hampton Roads Port of Embarkation facility Fort Eustis became a permanent installation, which brought even more people into Warwick County. In 1945, Warwick County reorganized its governance and moved its administrative offices from Lee Hall to Hilton Village. No longer a unique enclave in rural Warwick County, Hilton had become part of a greater suburbia. While the Hubbard-proposed Hilton Extension evolved into Brandon Heights, other developments were created along River Road, such as Rivermont, Warwick on the James, and Riverside. The area soon became known as Greater Hilton. Newport News sought to annex the Hilton area, while the county became the City of Warwick to avoid this action. Nothing could stall the consolidation of Warwick and Newport News in 1957. The new City of Newport News maintained its offices in Hilton, and the growth required better roads. By the 1960s, Hilton was heading to its 50th birthday, yet something had to be done to ensure the preservation of America's first public planned community. The Colony Inn was demolished, and threats to Hilton's historic fabric could be seen everywhere. A lack of preservation guidelines regarding road improvements and nearby industrial and commercial expansion resulted in deviations to house designs and the streetscape. Nevertheless, the Hilton community joined together to secure protections like the National Register of Historic Places status and the creation of the Hilton Village Architectural Review Board. These steps ensured that Hilton would become one of the greatest treasures of Newport News. Hilton may have seemed like a diamond in the rough to some, but as former Newport News mayor Joe Frank noted, "with a little loving care and polish, it becomes once again, a shining star."

The rapid growth of connector roads around the village increased vehicle traffic. One of the first noticeable postwar changes to the lower Peninsula occurred on January 13, 1946, when buses replaced Citizen Rapid Transit's 28 trolleys in a smooth transition. "Gone was the familiar clanking of the rails, the clang of the driver's bell," reported the *Daily Press*, "and gone also was the trolley going off the overhead power pole as they often did before." Many changes were made to Warwick Road during the two decades after, but none seemed adequate. Main Street was extended across the C&O tracks to intersect with Jefferson Avenue. Main Street was also widened between Warwick Road and River Road in 1951. The street would again be improved when, on June 1, 1961, one C&O grade crossing was eliminated with the construction of an underpass. (Courtesy of *Daily Press*.)

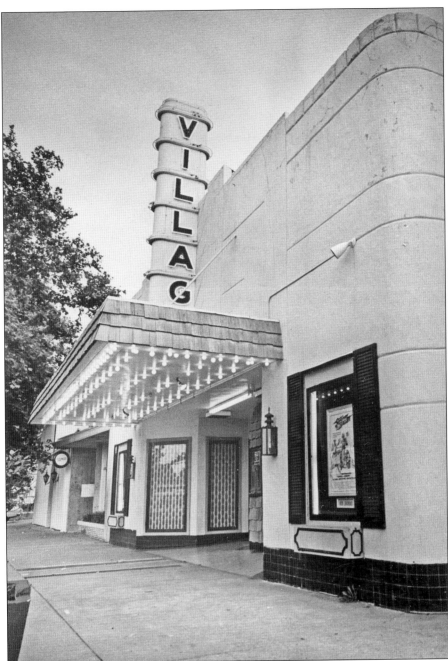

The Village Theatre opened on a chilly afternoon in February 1941 with the feature film *The Road to Singapore*, starring Bing Crosby, Bob Hope, and Dorothy Lamour. A reported 1,000 people queued up, and with only 400 seats, most had to wait for the next showings. Tickets were 20¢ for adults and 10¢ for children. The Village Theatre was built by Dominion Theaters, Inc., a chain that operated several other movie houses on the Peninsula. Hilton's theater had a stylish Art Deco facade, comfortable seats, and heavily carpeted floors. It boasted its own cooling system that featured a large block of ice with an even larger fan to blow cool air over the guests. As soon as air-conditioning was available, it was installed. (Courtesy of *Daily Press*.)

The Gordon brothers—Julian (left) and Jerome—purchased the theater and operated it for over three decades. Jerome Gordon noted, "We sure did sell that air conditioning." The theater was a mecca for children on Saturdays, as they could watch cartoons, a serial thriller, and then a feature film. Barbara Insley never forgot how she and her friends sent their children there during the summer when they played bridge. The theater attracted people of all ages. Kids could walk or ride their bikes, and they parked their "trusty steeds" in a large bike rack in front of Rose's department store. No locks were used, and as far as the records show, no bicycles were ever stolen. Of the Saturday matinees, Judy Andrews said, "I HAD to go every Saturday to see what happened to Tom Mix, Superman, and all the rest." Sudie Jones Shultz remembered how she would complain "when I was asked to walk all the way to Seward's for a loaf of bread; but, it was never too far to walk to the Village Theatre." After watching a film many people would go and have a snack at one of Hilton's pharmacies. Judy Andrews liked to go to "the drugstore on the corner across from Rose's. You could get a sandwich and a soda there. My sister was the 'soda jerk' there one summer." Others enjoyed going to White's Pharmacy for a hot fudge sundae from the soda fountain. (Courtesy of *Daily Press*.)

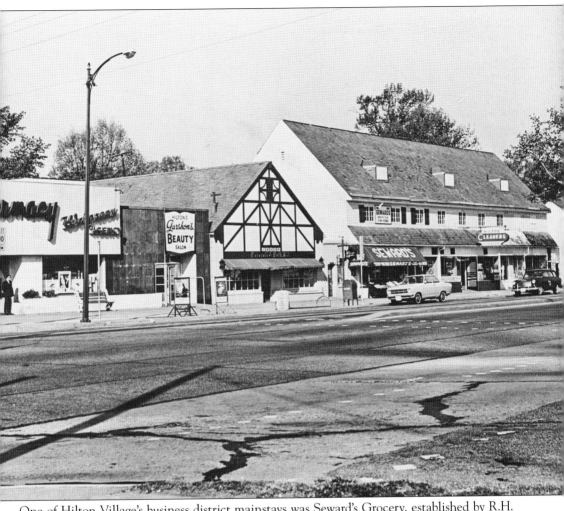

One of Hilton Village's business district mainstays was Seward's Grocery, established by R.H. Seward in 1918. The store displayed its fresh vegetables and fruits in baskets along the sidewalk out front. Patrons would decide what they wanted and then go inside to the counter to place their orders; clerks would retrieve their items. The small store carried many things, from bags of coal to gingersnaps to meat cut to order by the butcher. Often, housewives called in their orders and were able to get their groceries on credit. When the shipyard paid its workers every Friday, the husbands would settle the bill with silver dollars, the coins they were paid by the yard. When ordered, the groceries were delivered to customers' homes by panel trucks. One vehicle, known as the county truck, served homes from Brandon Heights to Shoe Lane, and the other focused on Hilton Village deliveries. David Seward recalled that almost "every lad in Hilton, probably drove one of those trucks. . . . This was when you could get a license at fourteen." Royden Goodson remembered the Seward's trucks "racing" through Hilton making their daily deliveries. If no one was home, the driver dropped off a cardboard box of food and supplies, placed directly inside the customer's kitchen. Many a young boy would try to get some free candy from Seward, who would often chase them away. Former state senator Marty Williams counted himself as one of Seward's friendly tormentors. Williams recounted, "We'd come through on our way to Hilton Pier and stop at the Hilton Pharmacy if we had any money. If we didn't, we'd go down and pester Mr. Seward out of something." (Courtesy of *Daily Press*.)

Compliments of

BEECROFT AND BULL

There were many popular stores within Hilton's business district that fostered so many joyful memories. Meredith West relished shopping there. She would roam around Rose's marveling at 12¢ bottles of perfume in beautiful blue glass and smelling Spanish peanuts being roasted. She loved poking around in Epes Stationery: "I always loved pretty paper and writing material, and was fond of Parker and Esterbrook pens." (Courtesy of Jamey Bacon.)

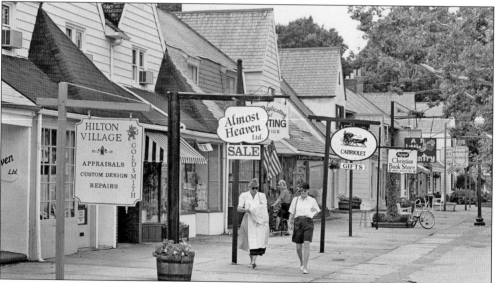

West also liked Mrs. Calhoun's Gift Shop, saying, "To my kid's eye, the store was full of intriguing artifacts." Her favorite store was Grace Spencer's shop with its "large, beautifully printed paned front window, and I remember enjoying the old fashioned atmosphere of her shop—pine paneling and wood-finished drawer fronts and cabinets. And enjoying the hometown perk of saying 'charge it' with no plastic involved." (Courtesy of *Daily Press*.)

The Colony Inn continued to be a popular destination immediately after the US Army ended its lease in December 1945. Emily Fournier remembered how the inn's entrance looked just after the war, stating that the "dining room was off to the right, once you passed through the main entrance. But if you turned to the left [toward Warwick Boulevard], the hotel registration desk was on the right, and on the left was a big bay window with a comfortable sofa beneath it. That area was all paneled in dark wood." The restaurant remained very popular. Groups like the Warwick Rotary Club held meetings at the inn for a few years. Barbara Osborne Granger remembered working as a waitress in the inn's small breakfast room, which could only seat six people or so. She noted that most of her customers were shipyard executives, including future yard president Bill Blewitt. Many college students like Virginia Shackelford Poindexter remembered going to the inn for "libations and handsome college boys." Even though the Colony Inn was still very well maintained and beautifully kept, it was in trouble. Lacking air-conditioning, elevators, and other modern appointments, the inn faced competition from newer hotels nearby. The south portion of the hotel was torn down in 1956. (Courtesy of John Lash.)

The Colony Inn's south section was replaced by the new Bank of Warwick, designed by the architectural firm Williams, Coile, and Blanchard. B.F. Rhodes, bank cashier and executive vice president, said this would be "a modern Bank building of two stories. . . . The first floor will include a modern lobby of entirely new design." The inn's northern section was replaced by the Chesapeake and Potomac Telephone Company in 1960. (Courtesy of Jamey Bacon.)

Prospects for Hilton's businesses dimmed when new shopping centers with unlimited parking began to open nearby, such as in 1953, when Hilton Shopping Center was established. It had ample parking and featured an A&P grocery store. Soon after, Warwick and Newmarket Shopping Centers followed. Newmarket offered 70 stores and hundreds of parking spaces. (Courtesy of Jamey Bacon.)

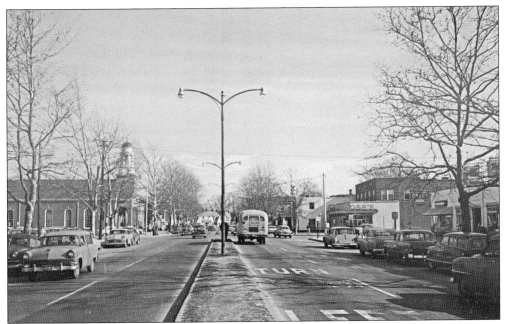

Hilton's businesses never had adequate parking once the automobile gave greater mobility to suburbanites. Bill Lee recalled the time he saw an elderly lady attempt to "wield a chrome-encrusted, great American land yacht into a parking space far too small, thereby tying up traffic for blocks." (Courtesy of Jamey Bacon.)

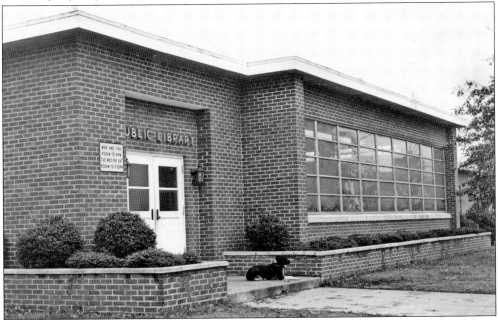

The City of Warwick endeavored to improve the new municipality's quality of life. A new library building, the Warwick Public Library, was constructed in 1954 at the Main Street Administration Complex. The Woman's Club of Hilton Village raised $15,000, which was matched by the city, to build the structure. The James River Garden Club beautified the library's grounds. (Courtesy of NNPL.)

An effort was begun on January 8, 1955, to consolidate the cities of Hampton, Newport News, and Warwick. The Virginia General Assembly passed legislation in March 1956; however, the City of Norfolk blocked the use of the name Hampton Roads. This doomed this consolidation movement, and Hampton voters defeated the measure at the polls on November 6, 1956. Yet the pro-consolidation forces refused to surrender and focused their attention on the union of the cities of Newport News and Warwick. A consolidation referendum was held in 1957 approving the union of the two cities. The merger was formalized on July 1, 1958. The new City of Newport News organized its administration at the old Warwick City Hall at Municipal Lane off of Main Street until the construction of the new city hall downtown was completed in 1972. (Courtesy of *Daily Press*.)

Ever since its construction, the Hilton Pier has been a landmark of the village and was a great place to enjoy the James River. Mary Bateman, whose grandmother lived on Main Street, remembers that her father, a shipyard designer, built her a sailboat; her mother made the sails, which "added to the many hours of luxurious and laughing times on the river." While a commonplace saying was "Meet me at the beach," late summer swimming was a challenge due to the arrival of troublesome jellyfish. Swimming lessons were not only arduous—a student had "to swim out to two red buoys and back," remembered Bateman—but "the sting of the jellyfishes made you swim faster as you couldn't wait to rub sand on the stings to help ease the pain." (Courtesy of Jamey Bacon.)

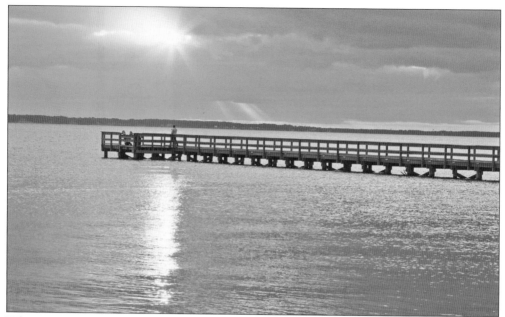

When one did not want to swim, dodging jellyfish, one could crab off the pier. Mary Catherine Dunn recalled "walking the shallow water next to the pier, picking up soft crabs" with her mother. Everyone loved the pier, and summer activities were planned around the tides, heat, and the wind. "You didn't need a pool," Mary Bateman recollected; "you had the James River." (Courtesy of *Daily Press*.)

One of the most popular (and scary) spots was the "Ravine" next to Hilton Elementary School. This small, forested park retained some of the original trees from the Darling Tract. Henry Hubbard had envisioned this woodland as part of the Hilton experience. A small brook ran through the gully that carried water from storm drains to the river. (Courtesy of *Daily Press*.)

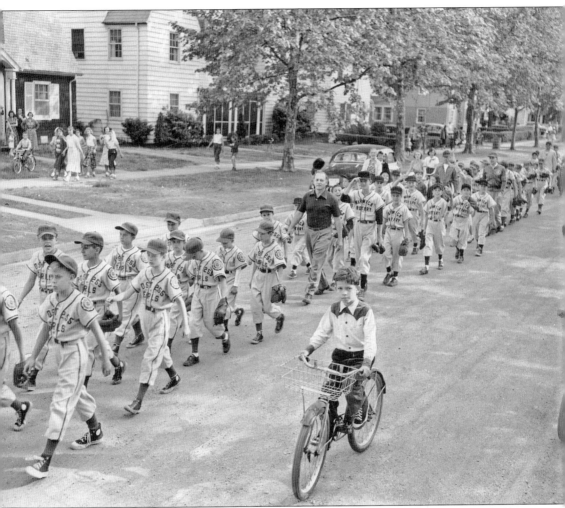

Many children experienced the mystical sense and spookiness of the Ravine. Jane Marshall remembers allowing her imagination to roam, dreaming that she was with Lewis and Clark, heading west through the wilderness. While the overgrowth and hanging vines have recently been cleared, memories of the Ravine still linger, especially of the places where the "bad guys" or "scalping Indians" might have been hiding. One of the biggest events of a typical year was the opening day of the Hilton Village Little League Baseball season. David Legg fondly recalled his 1970s Little League memories: "The day began with each player wearing their spanking new uniforms." They would begin the march in front of the Hilton school, parading up Main Street, across Warwick Boulevard to the Little League field behind the Methodist church. There were four teams: the Lions, Tigers, Bears, and Rams. Since the Hilton Tennis Club was right next to the baseball field, a home run might end up on the court. "The tennis players," Woody Parish jokingly recalled, "would yell, 'Look out, incoming ball.' " (Courtesy of Jay Lambiotte.)

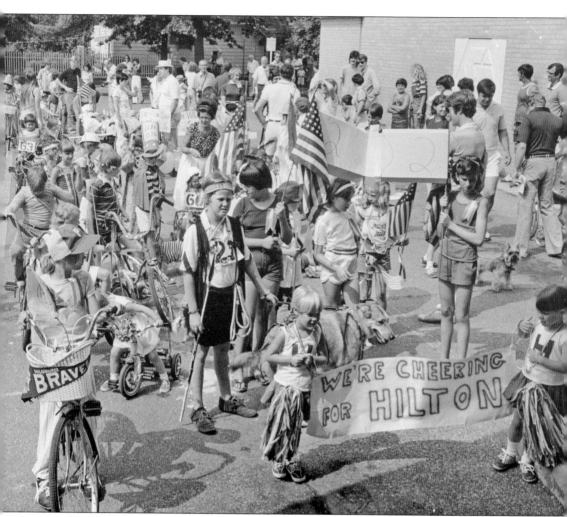

Hilton Village celebrated its golden anniversary on July 4, 1968. It rained like it did on the village's opening day, July 7, 1918, but this time, there was no mud and all the houses were even more charming. A parade marched down Main Street to Hilton Elementary School, where student Gary Hudson, who represented four generations of the Hudson family living in Hilton Village, raised the flag on the pole that was erected in 1918. A former mayor of the city of Warwick, George Abernathy, quoted former shipyard vice president Frederick Palen's 1918 comments: "The houses here are of a permanent character, neat design and built of good material." Everyone recognized Hilton's historical uniqueness and celebrated how wonderful it was to live in the village. Then Newport News mayor Donald Hyatt, a Hilton resident, noted, "This community has a true heart and a special historical uniqueness that cannot be found anywhere else in Newport News." (Courtesy of *Daily Press*.)

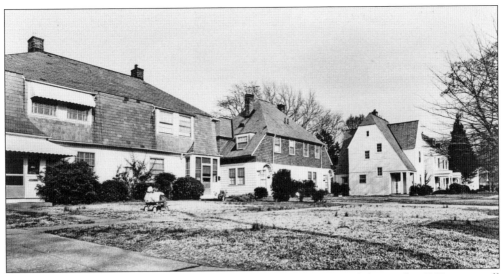

As Hilton turned 50 years old, many of the families who had arrived during the 1920s were still living in the village. These pioneers were being joined by younger families who recognized Hilton as a perfect place to raise their children. Yet many villagers realized that Hilton was under threat by the continued press of urban Newport News. (Courtesy of *Daily Press*.)

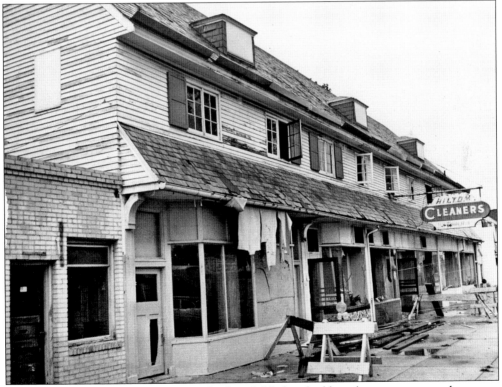

Hilton's business district had been greatly altered. Modern buildings began to appear where once majestic Jacobean-style structures stood. The large building containing the Hilton Auditorium, Seward's Grocery, and a barbershop was demolished. Many storefronts had been altered. Signs of every variety and without aesthetic consistency littered the wide sidewalks. (Courtesy of *Daily Press*.)

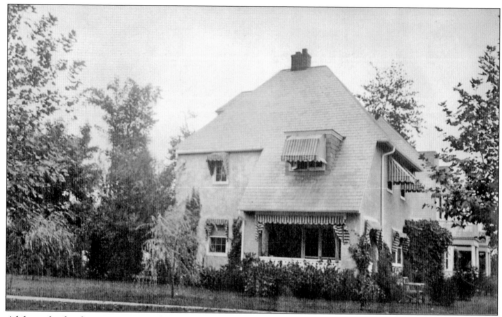

Although the houses retained their English cottage look, many homes had been modernized with non-complementary additions or porches. House colors were now varied, quite a departure from the original, mostly white exteriors. Something had to be done to protect Hilton from the effects of change and age. (Courtesy of NNPL.)

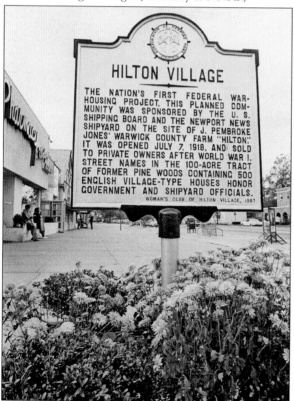

Fortunately, two groups, the Hilton Village Civic League and Historic Hilton Village Inc., joined forces to have Hilton named a Virginia Historic Landmark and placed in the National Register of Historic Places in 1969. The Newport News City Council strongly supported this designation and took steps to ensure that the city's first historical district would be preserved in keeping with the Hubbard-Joannes team's original designs and concepts. (Courtesy of NNPL.)

The Hilton Village Architectural Review Board (HVARB) was created by Newport News City Council in September 1972. The board had to prepare and maintain guidelines to protect and preserve the village's character. Its September 1974 issue of the *Homeowner's Guide* states: "The board consists of nine members. Two members are drawn from the City Planning Commission. One must be an architect and one an artist or landscape architect. Three members are resident owners of Hilton Village, and two must own or operate businesses in Hilton Village. This gives wide representation of membership, affording a voice to the various groups which have an interest in the maintenance of the Historic District." Its purpose was to ensure that any alterations or additions to property were harmonious to the village, matching the house designs of Francis Joannes. Hilton's sanitation engineer, Francis Bulot, advocates in a 1916 article he wrote for the *American City* magazine that Garden City developments needed some type of community control. Although he believed that neighborhood associations were required to look after the interests of an area's residents, the engineer strongly advised that restrictions be emplaced limiting the use of and alterations to houses within a planned community. Bulot thought that these guidelines created "a community spirit" that established "a harmony of color and texture of building that has given charm to their surroundings" and must be properly maintained. (Courtesy of *Daily Press*.)

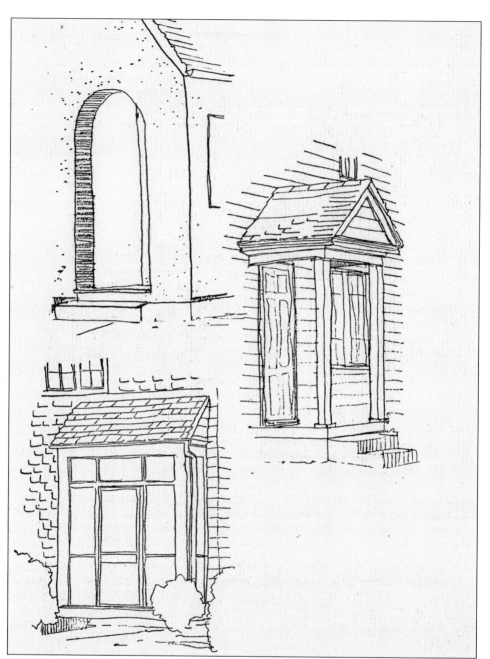

The National Register designation and the HVARB brought strict limitations on paint colors, fences, extensions, signage, and gutters. Any exterior work had to be approved by the board or review agent. Painting or siding was not considered routine maintenance, and those improvements required approval, which guarded the quaintness, ambience, and security of the village as a close, cohesively knit neighborhood. These actions helped maintain Hilton's image. The *Homeowner's Guide* further states: "It is not the duty of the Review Board to pass upon the attractiveness or convenience of an alteration or addition but solely to insure its authenticity and appropriateness to the Village theme." Interior changes did not require board approval "unless such work would affect the exterior appearance of the building." (Courtesy of City of Newport News.)

The review board endeavored to ensure that any changes were in keeping with Joannes's original designs. The board's main job was to review building permits, thereby issuing a certificate of appropriateness when projects met the guidelines in the *Homeowner's Guide*. This guide aided property owners in knowing how to maintain Hilton's historical integrity. (Courtesy of City of Newport News.)

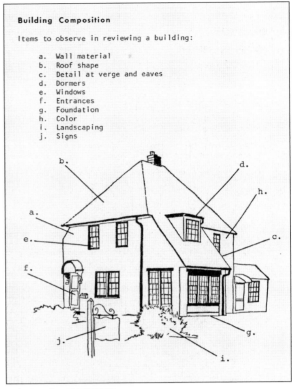

Building Composition

Items to observe in reviewing a building:

a. Wall material
b. Roof shape
c. Detail at verge and eaves
d. Dormers
e. Windows
f. Entrances
g. Foundation
h. Color
i. Landscaping
j. Signs

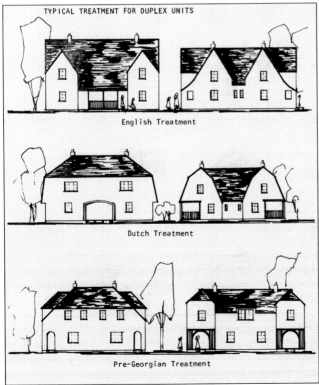

TYPICAL TREATMENT FOR DUPLEX UNITS

English Treatment

Dutch Treatment

Pre-Georgian Treatment

The review board was established with the best of intentions; nevertheless, certain guidelines (such as aluminum siding and shutter replacement) were questioned. The HVARB does not have the power to reinforce its rulings if changes are completed without a building permit. The board also cannot require property owners to clean up their yards, fix up their houses, or keep residents from parking on the grass. (Courtesy of City of Newport News.)

An issue that brought Hiltonites together to fight city hall was the widening of Warwick Boulevard as it turned through the village. The City of Newport News was striving to solve the traffic bottleneck at the intersection of Warwick Boulevard and Main Street by widening Warwick from four to six lanes. This road improvement plan was one of the reasons why Hilton Village had sought historical designation, and the villagers once again rallied to fight the street widening using several tactics. A compromise plan was submitted featuring five lanes that was presented to then mayor Joe Ritchie. He thought it was a viable option. Residents feared that the business district would suffer if the wide sidewalks along Warwick were narrowed for the road widening. The issue that everyone rallied around was a majestic oak tree, located at 10217 Warwick Boulevard. The oak, which was far older than Hilton itself, would surely die if its root system was damaged. It became a symbol of the villagers' lobbying efforts to convince city council to follow the five-lane solution. (Courtesy of *Daily Press*.)

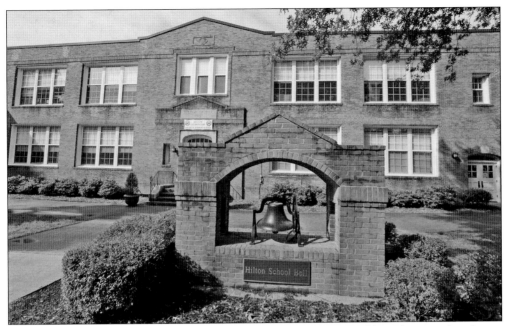

Hilton Elementary was a key component of the village. Residents could set their watches during the school year by the tolling of the school bell. Author Bill Styron remembered the principal, spinster Alice M. Menin, as not being a strong disciplinarian, but she believed in high standards achieved in a relaxed atmosphere. When it rained, she would close the school at lunchtime so students could go home and play games like Monopoly. (Courtesy of Michael Poplawski.)

Jackie Legg Wash remembered teaching at Hilton Elementary beginning in 1966. She has nothing but "wonderful memories of my riverfront classroom on the second floor, even though the windows were far from airtight and both wind and snow blew in on cold days, causing us to rearrange furniture to stay warm." (Courtesy of Jamey Bacon.)

Hilton Elementary's classrooms' age, like that of the village itself, "gave classes a sense of unity," said Jackie Legg Wash. She remembered the school did not have a gym, so "we were on the playground in almost any weather. . . . Our second most important piece of P.E. equipment was the crab net, since kick balls easily landed in the river. . . . The fastest boy would grab the net and race to the beach or pier to retrieve it. . . . Never lost a student or a ball." (Courtesy of Jamey Bacon.)

Once students graduated from Hilton Elementary, they attended Warwick High. Date nights were really special. Leo Williams remembered that he had just 80¢ to cover his date, but this was enough to watch a movie at the Village Theatre, eat popcorn, and then have sodas and sandwiches at a village drugstore. Hilton was the center of the universe for most young people those days. (Courtesy of Jamey Bacon.)

One of the most talented graduates of Hilton Elementary School in the post–World War II era is conductor Will Crutchfield. His father became pastor of Hilton Presbyterian Church in 1966. While still in high school in 1975, Crutchfield signed on with the newly established Virginia Opera. After graduation from Northwestern University, Crutchfield became a specialist in the bel canto repertoire. He prepared the first performance of Donizetti's *Elizabeth ou la fille de l'oxcile* and conducted the world premiere at the Caramoor International Music Festival in Katonah, New York, on July 17, 2003. Other achievements include his being the *New York Times* music critic from 1999 through 2005; serving as music director of the Opera de Columbia in Bogotá; and appearing as frequent guest conductor at the Polish National Opera in Warsaw. One critic said Crutchfield's conducting style is "a fine balance of bravado, intensity, sensitivity and scholarly savoir-faire." This outstanding musicologist is now director of opera at the Caramoor International Music Festival, where he also teaches the next generation of singers, reviving many oft-forgotten or rare operas. (Courtesy of Fletcher Artist Management.)

Yet another graduate of Hilton Elementary who achieved artistic success is actor Gary Hudson. Born on March 26, 1956, in Newport News, he was raised in Hilton, where his father was also born. In his teens, Hudson played tennis, taught swimming lessons, and served as a lifeguard at the Hilton Pier. He attended Christopher Newport University, playing tennis, and, as he said, "floundering at school work for two years." He was then off to Hollywood by way of Boulder, Colorado, to pursue an acting career even though he had no acting experience. He landed his first role in the film *Hooper*, starring Burt Reynolds. His career includes the cult classic *Roadhouse* with Patrick Swayze. Hudson is known for his roles in television series such as *Safe at Home* and *As the World Turns*, as well as a recurring role on *Dynasty* and guest appearances on *Cold Case* and *Three's Company*. He maintains dual citizenship in the United States and Canada, where he was nominated for Best Actor at the 2009 Monte Carlo International Film Festival for his role in *Wild Roses*. (Courtesy of Beverly Hudson.)

Barclay Sheaks was a newcomer to Hilton when he and his wife moved into their home at Hopkins Street and River Road in 1949. He had just accepted a position teaching art at Warwick High School. Born on October 22, 1928, Sheaks grew up in a family that was nurturing and supportive of his talent as an artist. Sheaks grew up near Newmarket, Virginia, in the Shenandoah Valley where his fascination with the wonders and beauty of nature began. He was a graduate of Richmond Professional Institute (today's Virginia Commonwealth University) and received a master's degree in art from the College of William and Mary. He later was awarded a doctorate of humane letters from Christopher Newport University. Sheaks taught at Warwick High School until 1967, when he was asked to establish the art department at Virginia Wesleyan College (now University). He retired in 2008 after teaching thousands of students in an encouraging manner. Sheaks was "an inspiring example of someone who could make a living here by teaching and making art," noted former student James Warwick Jones, now director of the Charles H. Taylor Art Center in Hampton. Jones added, "That made him one of the most important art figures on the Peninsula." Sidney Jenkins, who studied art with Sheaks at Virginia Wesleyan and is now director of New Jersey's Ramapo College Art Gallery spoke of his teacher, saying, "He was a very important father figure for me—and I learned a lot by watching his miraculous demonstrations. He had a real gift for introducing people to art. . . . He could lead people who wouldn't otherwise be interested in ways not many others can. I still hear his voice when I think about the teachers I've had." (Courtesy of *Daily Press*.)

Barclay Sheaks carved out a record of influence, critical acclaim, and financial success that most other artists in the region can only envy. His paintings were displayed at the Virginia Museum of Fine Arts in 1967, resulting in a Best of Show award, confirming his excellence in acrylic painting. "He had an original way of seeing things," Jones said. "One of his paintings I remember was after a storm, and there were rocking chairs on the beach and the tide and wind had almost covered them in sand. It suggested the forces of nature," and was poetic, he continued. Sheaks authored eight books, including *Stretching the Eyes Distance* and *Painting with Acrylics: From Start to Finish.* He also hosted an art instruction program on PBS called *Acrylic Painting with Barclay Sheaks.* A generous supporter of the Hampton Roads art scene, he was a member of the Hilton Village Architectural Review Board and the Newport News Public Art Foundation. Sheaks's wife, Edna, noted that her artist husband was just a "watcher" and would make her stop the car often and at random so he could capture a scene and its mood in his mind. Artist James Warwick Jones reflected that Sheaks "had an original way of seeing things. One of the many paintings I remember was after a storm, and there were rocking chairs on the beach and the tide and wind had almost covered them with sand." Sheaks died on April 13, 2010. (*Bay Totem* by Barclay Sheaks, collection Virginia Wesleyan University, courtesy of Virginia Wesleyan University.)

Eight

HILTON VILLAGE'S CENTENNIAL

As Hilton Village prepared for its 75th anniversary, many actions had been accomplished. The National Register status and the Hilton Village Architectural Review Board ensured that Hilton would not become overwhelmed by the needs of the city of Newport News. The review board guidelines had a very positive impact on maintaining the serenity of Hilton's English cottage look. Nevertheless, other major issues still needed resolution to ensure that America's first federally funded planned community maintained the Garden City–New Urbanism concepts woven into it by Hubbard and Joannes.

All the homes were extremely well built despite being very economical to construct. This is demonstrated in the ways in which, in the 21st century, houses can be maintained and expanded in keeping with HVARB standards. Hilton was created as its own unique community with schools, shops, and churches all laid out with the belief that a worker's efficiency increases when his living conditions are improved. Despite the modern attributes that were invested in Hilton, it was steeped in the past. As such, it was a model for future developments.

Two critical functions were achieved between the village's 75th and 100th anniversaries: the retention of the Main Street Library and improvements to the business district. Both projects would have tremendous impact. The new library complemented Hilton's architecture and continued a dream begun by the Hilton Village Woman's Club in the 1930s. Likewise, a major upgrade to the business district, including decorative sidewalks and planters, improved the English village style of the district and welcomed shoppers and foodies alike to enjoy the Hilton experience in a finer fashion than ever before.

All of these activities prompted former Newport News mayor Joe Frank to state in 2009, "Hilton is a crown jewel in our community." Hilton has evolved in so many ways since 1918; however, it is a village that was built to last. It continues to provide residents and visitors with a rich and rewarding life experience.

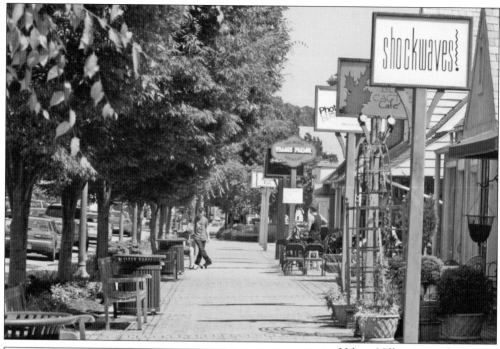

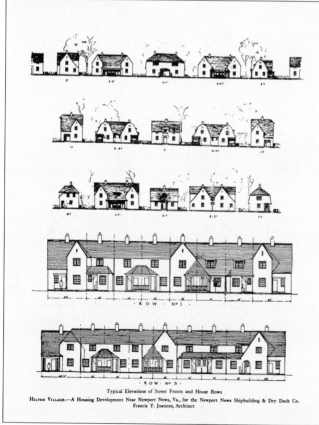

Typical Elevations of Street Fronts and House Rows

HILTON VILLAGE.—A Housing Development Near Newport News, Va., for the Newport News Shipbuilding & Dry Dock Co.
Francis Y. Joannes, Architect

Hilton Village was often referred to as the "Gem of the Peninsula," a unique blend of commercial and residential buildings with distinctive English village–style architecture. Hilton survived because its residents cared and were willing to take political action to ensure the treasured community's tapestry was preserved. (Courtesy of *Daily Press*.)

Several organizations worked together to prepare Hilton for its 75th anniversary in 1993. During the early 1980s, the Hilton Village Civic League and the Hilton Village Garden Club emerged to forge a new nonprofit organization. This group, Historic Hilton Village Inc., was determined to support a variety of improvements, adding to the community's well-being. (Courtesy of City of Newport News.)

Another organization, established in 1979, was Citizens for Hilton Area Revitalization (CHAR), focused on business district improvements as well as the gateways into Hilton from Center Avenue along Warwick Boulevard to Shirley Avenue. CHAR played an important role as a liaison with the City of Newport News Planning Department, lobbying to maintain Hilton's integrity through preservation actions. Jim Wallace, former chair, HVARB, is pictured. (Courtesy of *Daily Press*.)

The planned anniversary celebration featured events throughout 1993. Numerous events were held, including a pink flamingo garden tour, a May Faire in the business district with sidewalk art displays, and eight October Community Days of Celebration with speakers, music, and programming. An ecumenical service at Hilton Baptist Church was held on October 9, 1993; Hilton's four churches and their roles in developing the community were praised. (Courtesy of *Daily Press*.)

A highlight of the anniversary celebration was the October 23, 1993, return of award-winning author William Styron to his hometown of Hilton Village. The Junior League sponsored a dinner in his honor during which he spoke about his newest book, A Tidewater Morning, which Styron considered "an emotional return to my origins." Many who attended were shocked by his first novel, Lie Down in Darkness, which was set in the mythical town of Port Warwick but based upon the people, places, and events of Newport News. Mary Sherwood Holt noted that the "language, the themes—death, sex, betrayal. What else do you need? There were 25,000 people here back then. They all knew each other, and don't think they didn't know all of the characters." Ernest Buxton noted that if Styron "needed to be, he has been forgiven. Maybe we're just star struck." Styron took time to return to Hilton Elementary to speak to the students in the auditorium. It was all a marvelous way to celebrate Hilton's continuation as a special place to live. (Courtesy of John V. Quarstein.)

The celebration highlighted many fond memories for everyone associated with the village. Harry and Mary Holland grew up in Hilton and moved away once they were married, but they soon came back. Mary noted, "We all liked living here as kids and think that it is still a nice place to live today . . . the village . . . is the same charming place I remember as a child." (Courtesy of Jamey Bacon.)

During the 1990s, the residential area of Hilton was thriving; however, the commercial district needed help. A major issue arose about the replacement of the old Warwick Public Library. Organizations like CHAR, Historic Hilton Village Inc., HVARB, and the Newport News Historical Commission joined to convince city council to build the new library on Main Street. Then vice mayor Marty Williams summed up the issue by saying, "What is a library to a community? It's a focal point." (Courtesy of Michael Poplawski.)

Hiltonites were overjoyed that the library would be kept at Main Street. The Newport News–based architectural firm of Rancorn, Wildman, Krause and Brerzinski was selected to design the new library. Jim Pociluyko was the project manager. While he knew that the building had to meet the functional and practical needs of a library, Pociluyko also felt that "the building has to relate to the historic Hilton Village and the surrounding churches, and it needs a sense of visual excitement." The library's high-pitched slate roof, brick facade, and central bay window beautifully reflect the city's commitment to Hilton's future. The project began with the razing of the existing 5,000-square-foot Warwick Library building, built in 1950 by the Woman's Club of Hilton Village. The books were moved to a nearby vacant Rite Aid store, thus allowing the library to continue serving its clientele. Work on the new library began in 1993. The new Main Street Library, opened in 1996, was a $3.3 million facility that provided space for 130,000 books along with space for studying, learning, and meetings. A dedicated room for the Martha Woodroof Hiden Memorial Virginiana Collection, featuring genealogy records as well as maps and papers from Collis P. Huntington's Old Dominion Land Company, was a highlight. Furthermore, the library provided space for the Subregional Library for the Blind and Physically Handicapped. (Courtesy of Michael Poplawski.)

A Hilton renaissance was truly under way when a series of federal grants underwrote a number of improvements that were completed in 1997. The revitalization plan received the Distinguished Award from the Virginia Chapter of the American Planning Association. Paul Miller, then director of Newport News Planning and Development Department, noted, "A lot of good people are contributing to improvements that we hope will have a meaningful impact." (Courtesy of *Daily Press*.)

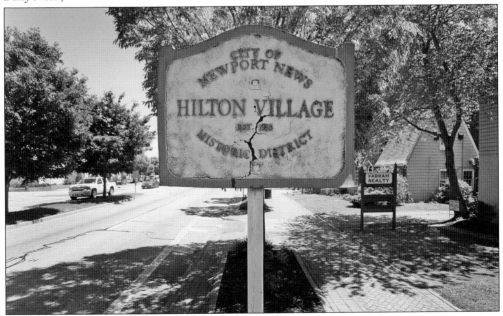

The new plan required some zoning adjustments, including allowing restaurants to offer outdoor seating and instituting reduced parking requirements. These ordinances were changed to enable Hilton Village to begin its expansion as a dining destination. The streetscape dedication project ceremony was held on February 29, 1996. (Courtesy of *Daily Press*.)

With the new sidewalks, CHAR organized a group to paint the business block along Warwick Boulevard. CHAR president Jeff Stodghill remarked, "Tidying up the shop facades will help make the village more attractive to businesses and shoppers." The Hilton Village Merchant Association sponsored several Christmas-themed events in 1997. The Holiday Illumination was held on December 5, beginning with the annual Christmas tree lighting at Hilton Elementary. Cheerful festivities continued in the business district with caroling and trolley rides. The highlight of the season was an up close and personal "street tour" production of Charles Dickens's A Christmas Carol. The York County Northside Church of Christ music and drama department provided the actors, who wore 19th-century-style costumes. The tour began at the Hilton Village Woman's Club; Ebenezer Scrooge served as the guide. (Both, courtesy of Daily Press.)

Attendees were led down the "colorful streets of Olde London," encountering characters like Bob Cratchit and Tiny Tim. "Everything we need for this performance is right here in Hilton," noted director Joe Ellen Anklam. "Where else on the Peninsula could you find such an appropriate setting? Hilton Village has the look we were envisioning." Jeff Stodghill noted, "Hilton's historic character is now perceived as offering something unique." (Courtesy of *Daily Press*.)

Jerome, Julian, and Leonard Gordon, owners of the Village Theatre, had continued operating the single-screen venue after the emergence of multiplex theaters. Accordingly, the Village Theatre was converted from a first-run to a sub-run theater in the early 1980s, where new movies took longer to arrive but prices remained low, $1.50 a ticket most nights. What had changed, Jerome Gordon reflected, was that there was more competition. (Courtesy of *Daily Press*.)

The Village Theatre remained a popular venue for Hiltonites. Leo Williams spent almost every Friday night there for years and believed it was "the mecca of the Hilton area." Nevertheless, the Gordon family sold the Village Theatre to the Peninsula Community Theatre in 1993. The Village offered its finale on May 26, 1994, featuring the films *Guarding Tess* with Shirley MacClaine and *Tombstone* with Kurt Russell. (Courtesy of Michael Poplawski.)

The new owners of the Peninsula Community Theatre (PCT) were dedicated to maintaining the theater as a positive part of Hilton. The movie theater was converted into a venue for live stage performances and was completed just in time to open with the Broadway hit *Chicago*. Today, PCT remains committed to five main stage productions and a popular series of children's shows. (Courtesy of Peninsula Community Theatre.)

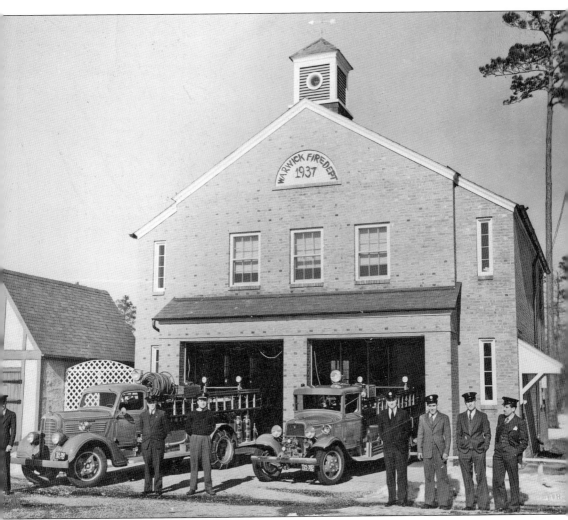

The 1937 Hilton Firehouse was deemed obsolete in 2005 by the Newport News Fire Department as it was too small to meet modern needs. The brick building featured just three bays; the space was only 1,400 square feet. It had been designed for the smaller fire trucks of the 1930s and 1940s. The fire department received funding from Newport News City Council to construct a new station near the Midtown Community Center, about one mile from the 1937 fire station. The new facility was completed in 2011. Meanwhile, concerned city officials and Hilton residents formed a committee to seek a solution for the adaptive reuse of the 1937 firehouse. A few thought a brewery might work, but it was too close to the Baptist and Methodist churches. Some thought a museum might be the answer, but others believed a library annex might be best. While the city continues to maintain the structure, nothing had been decided by the time this book went to press. (Courtesy of NNPL.)

One of the last full-service gas stations on the Peninsula, Adams's Amoco Station was located just south of Hilton Village, next to the "Hilton Country Club." The station closed in 2008, and the Green Foundation secured this 1929 building. It is now utilized as a Newport News Police Department substation and houses displays about the city's police department and Hilton Village. (Courtesy of Michael Poplawski.)

Another iconic spot just outside the village was Adams's Place, which operated as a tavern since the 1930s. The owner, Ray Adams, used to torment young William Styron when he collected his papers there for delivery. At one time, it was the only tavern between downtown Newport News and Denbigh. Better known as the "Hilton Country Club," it now operates as Hilton Tavern Brewing Company. (Courtesy of Michael Poplawski.)

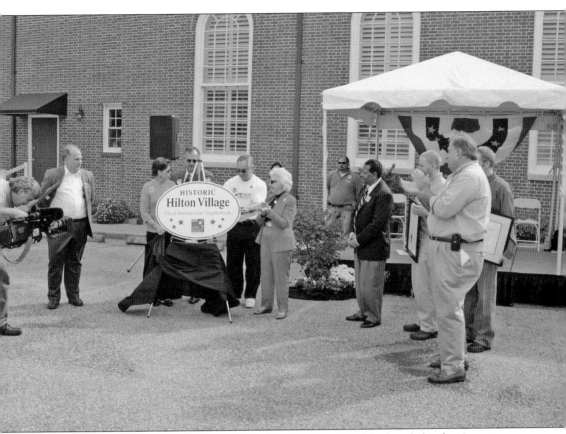

In 2009, Hilton Village was named one of the Top 10 Great Neighborhoods by the American Planning Association (APA), the professional organization representing the field of urban planning in the United States. Johnnie Davis of the Newport News Planning Department and the city's liaison with the HVARB submitted Hilton's application to the APA. In the proposal, Davis recognizes that Hilton Village met all of the requirements of a great neighborhood, and he acknowledges the vision of Henry V. Hubbard in providing the village with defined borders, a business district, and gridiron street patterns. Being modeled on Sir Ebenezer Howard's Garden City movement in Great Britain, the village utilized economy of space and variable designs reflecting English village architecture, including parks, to create a friendly, open feel. From its inception, Hilton had a unique sense of place, and its people have always been engaged in the well-being of the community. These elements joined to earn Hilton Village its place on the Great Neighborhoods roster. The APA recognized Hilton as "an iconic example of timeless neighborhood planning concepts." (Courtesy of Michael Poplawski.)

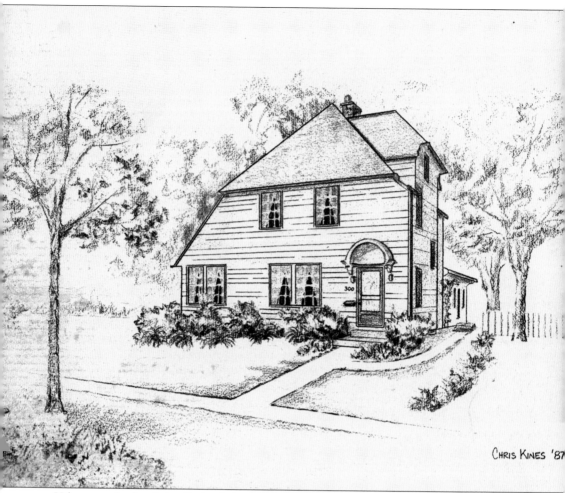

CHRIS KINES '87

Hilton was the first federally funded expression of the British Garden City movement. A planned garden community battles the evils of the inner city, allowing a focus on family protected from a rapidly growing modern industrial world. It was a utopian socialist housing movement that utilized the English cottage tradition coupled with harmony and unity. Accordingly, Henry Hubbard and Francis Joannes achieved an upwardly mobile theme, epitomized by using high-sloping roofs, large central gables, dormers, and different building materials. The clustering of duplexes within the streetscape gave Hilton a distinct commonality and symmetry without sameness. Over the years, many new families moved to the village to gain that sense of community. Joseph and Lula Buchanan were one of the families who settled into their Hurley Avenue home in 1930. Their daughter later lived on Hopkins Street, and their son became assistant rector of St. Andrew's Episcopal Church. (Courtesy of Jamey Bacon.)

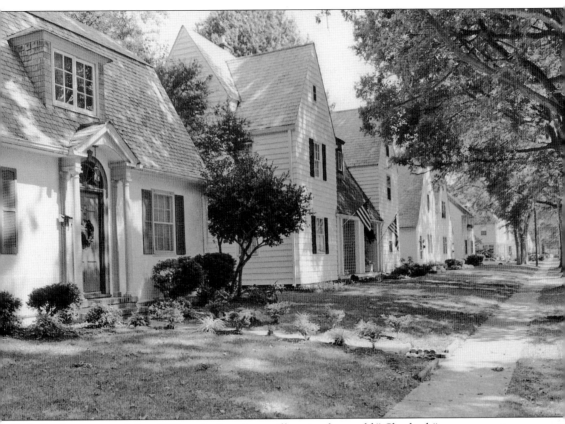

Lula Buchanan noted that "Hilton is the nicest village in the world." She had "never seen so many children in the world." More than 70 years later, Chad and Karen Martin moved into their Ferguson Avenue home in 2001. Karen noted that Hilton was not her first choice for a neighborhood to raise her son and that their house was not the one of her dreams. These feelings were quickly changed as she embraced the "Hilton way." She said how easy it was to transform her home into the perfect abode, "worth a million" to her family. Their son attended Hilton Elementary. Both she and her husband can walk to and from their businesses on Warwick, just as many did a century before. A thousand or more other families have been drawn to this quaint village sited along the James River. The streetscape and architectural designs depict an alluring sense of comfort and unity. The tapestry of Hilton continues to be woven and preserved as the village becomes 100 years old. (Courtesy of *Daily Press.*)

Complex in its planning and design concepts that sought better living conditions for skilled shipyard workers during World War I, Hilton Village continues to be a thriving center of suburban life. Hilton was developed in an area an unheard-of two miles from its residents' employer, Newport News Shipbuilding, way out in the woods of Warwick County. Even though it was established as emergency housing, the Hubbard-Johannes team made sure that Hilton would be lasting and enduring. The initial planning and house designs and placement, as well as its subsequent construction, combined to foster a tremendous sense of community pride. As a self-sufficient town, Hilton has grown into a community where the preservation of architecture and design is appreciated and cherished. It is the first government-funded planned wartime housing development built especially for the working class, allowing its residents the opportunity to advance to the middle class and beyond. (Courtesy of Michael Poplawski.)

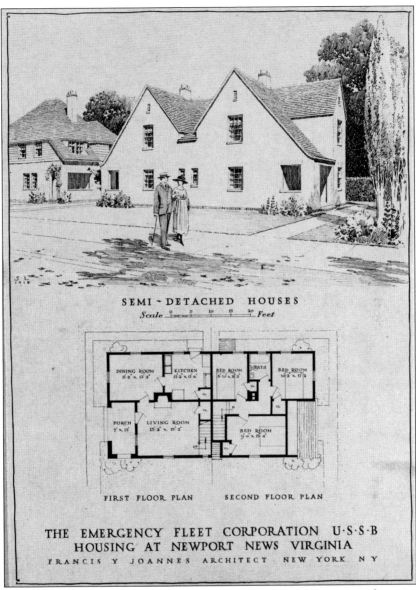

SEMI - DETACHED HOUSES
Scale 0 5 10 15 20 Feet

FIRST FLOOR PLAN SECOND FLOOR PLAN

THE EMERGENCY FLEET CORPORATION U·S·S·B
HOUSING AT NEWPORT NEWS VIRGINIA
FRANCIS Y JOANNES ARCHITECT NEW YORK N Y

Hilton Village offers a pleasant combination of family, friends, teachers, artists, shop owners, and regular folks who all relish Hilton's attributes. The river, the pier, the wide sidewalks, the canopy of trees, nearby shops and restaurants, and awesome architecture, all highlighted by the Garden City movement's planning concepts, provide residents a sense of vitality, value, and variety. Hilton's special charm was inspired by the need for emergency housing for the workers building ships for Victory. The village has grown in many ways since 1918, but it has retained its appeal and magic. As former Newport News mayor Joe Frank noted in 2009, "Hilton Village is a crown jewel in our community." Indeed, Hilton is the embodiment of public-spirited policy seeking the permanence of dwellers as a new-style suburban community. Consequently, Hilton Village is a tremendous town that was built to last, and it continues to provide residents and visitors alike with a rich and rewarding life experience. (Courtesy of Harvard Art Museums/Fogg Museum, Transfer from the Carpenter Center for the Visual Arts, Social Museum Collection. Photo: Imaging Department © President and Fellows of Harvard College.)

SELECTED BIBLIOGRAPHY

Brown, Alexander C. *Newport News' 325 Years: A Record of the Progress of a Virginia Community.* Newport News, VA: Newport News Golden Anniversary Corporation, 1946.

Cardasis, Dean. "Land Forum: Landscape, Architecture, Garden Design & Environmental Planning." *Garden History*, 1998.

Chambers, Ruth Hanners. "Hilton Village: The Government's First Planned Community Was Built in an Emergency." *Virginia Cavalcade*, Spring 1967.

———. *Hilton Village: The Nation's First Government-Built Planned Community.* Newport News, VA: The Woman's Club of Hilton Village, 1967.

Creese, Walter, ed. *The Legacy of Raymond Unwin: The Rise and Fall of Suburbia.* New York: Basic Book, 1987.

Daily Press and *Times Herald* (Newport News, VA).

Gainer, Mary. "Lankes: Little-Known Artist of the NACA." *News & Notes* vol. 31, no. 1 (First Quarter 2014) and 2 (Second Quarter 2014). NASA History Program Office.

Glaab, Charles N. and A. Theodore Brown. *A History of Urban America.* New York: Macmillan Company, 1987.

Hilton Village Architectural Review Board. *Homeowner's Guide 1986.* Newport News, VA: Hilton Village Architectural Review Board, 1986.

Howard, Ebenezer. *Garden Cities of To-Morrow.* London: S. Sonnenschien & Co., 1902.

Hubbard, Henry V. "Hilton Extension." Washington, DC: US Housing Corporation, 1919.

———. "Some Preliminary Considerations in Government Industrial War Housing." *Landscape Architect* vol. VIII, no. 4 (July 1918).

Hubbard, Henry V. and Francis Joannes. "Government Industrial Housing: A Business Proposition," *The American Architect* vol. CXIV, no. 2224 (August 7, 1918).

Mantay, Amy Trexler. "An Evolution of the Preservation of World War I–Era Planned Communities." MA thesis, Welch Center for Graduate and Professional Studies, Goucher College, Master of Arts in Historic Preservation, 2003.

McAlester, Virginia and Lee. *A Field Guide to American Houses.* New York: Alfred A. Knopf, Inc., 1984.

McKelvey, Blake. *The Emergence of Metropolitan America, 1915–1966.* New Brunswick, NJ: Rutgers University Press, 1968.

Meacham, Standish. *Regaining Paradise: Englishness and the Early Garden City Movement.* Chichester, UK: John Wiley & Sons, 1999.

National Register of Historic Places Inventory: Nomination Form, June 23, 1969.

Newport News Department of City Planning. "Hilton Village after 50 Years." Newport News, VA: Newport News Department of City Planning, 1968.

Newport News Department of City Planning and Community Development. "A Report on the Hilton Village Survey." Newport News, VA: Newport News Department of City Planning and Community Development, 1971.

Perkins, Sara L. *The Fabric of a Neighborhood: Hilton Village in Newport News, Virginia.* Blacksburg: Virginia Polytechnic Institute and State University, 1995.

Quarstein, John V. *World War I on the Virginia Peninsula.* Charleston, SC: Arcadia Publishing, 1998.

Quarstein, John V. and Parke S. Rouse Jr. *Newport News: A Centennial History.* Newport News, VA: City of Newport News, 1996.

Rouse, Parke Jr. *Endless Harbor: The Story of Newport News.* Newport News, VA: Newport News Historical Commission, 1969.

Stevens, Charles N. *Back from Combat: A World War II Bombardier Faces His Military Future.* Bloomington, IN: AuthorHouse, 2011.

Stodghill, A. Jack. *Hilton Village after Fifty Years.* Newport News, VA: Newport News Department of City Planning, 1968.

Taylor, Welford Dunaway. *Robert Frost and J.J. Lankes: Riders on Pegasus.* Hanover, NH: Dartmouth College, 1996.

West, James L.W. III. *William Styron: A Life.* New York: Random House, 1998.

Discover Thousands of Local History Books
Featuring Millions of Vintage Images

Arcadia Publishing, the leading local history publisher in the United States, is committed to making history accessible and meaningful through publishing books that celebrate and preserve the heritage of America's people and places.

Find more books like this at
www.arcadiapublishing.com

Search for your hometown history, your old stomping grounds, and even your favorite sports team.